Picture This, Alaska

HISTORIC PHOTOGRAPHS FROM THE LAST FRONTIER

Edited by Deb Vanasse

Picture This, Alaska

HISTORIC PHOTOGRAPHS FROM THE LAST FRONTIER

SASQUATCH BOOKS
SEATTLE

To my parents, who raised me with a love of books and history.

Printed in Canada
Published by Sasquatch Books
Distributed by PGW/Perseus
15 14 13 12 11 10 09 9 8 7 6 5 4 3 2 1

Cover photographs: Barrett Willoughby Collection (front left); photo by P. S. Hunt, Crary-Henderson Collection (front center); Alaska State Library, Skinner Foundation (front right); photo by Ernest Blue, Alaska State Library, Winter and Pond Photographs (back). See pages 124, 126, and 129 for complete photo credits.
Cover and interior design: Rosebud Eustace
Interior composition: Rosebud Eustace

Library of Congress Cataloging-in-Publication Data
Picture this, Alaska : historic photographs from the last frontier / edited by Deb Vanasse.
 p. cm.
 ISBN-13: 978-1-57061-584-9
 ISBN-10: 1-57061-584-5
1. Alaska--History--Pictorial works. 2. Alaska--Social life and customs--Pictorial works.
3. Frontier and pioneer life--Alaska--Pictorial works. I. Vanasse, Deb.
 F905.P53 2009
 979.8'040222--dc22

 2008044902

Sasquatch Books
119 South Main Street, Suite 400
Seattle, WA 98104
(206) 467-4300
www.sasquatchbooks.com
custserv@sasquatchbooks.com

It is a land of strange sights and stranger experiences, where much that is never dreamed of in the south will be found to be the commonplaces of an unknown people . . . it is the land of sunless days and moonless nights; where Nature apparently has transposed the natural order of things, as is observed in southern latitudes, and inaugurated a new regime for visitors to wonder and marvel at.

—A. C. HARRIS, 1897

CONTENTS

Each year a larger number will learn about this magical territory; each year new bands of tourists will seek its marvelous panorama of glittering mountains and its rivers of flexible ice. No one who ever goes to Alaska fails to be impressed with the majesty of nature there displayed, and to rejoice that fifty years ago there were a few statesmen far-sighted enough to see the possibilities of that distant boreal land.

—N. H. DOLE, 1910

INTRODUCTION

Celebrating the history of the Last Great Place, this collection of high-quality original photographs resounds with the spirit of Alaska—spunk, pride, determination, loneliness, resilience, beauty, and enthusiasm.

Much was written—and overwritten—about Alaska, especially during its territorial years. Culled from these sources are historical quotes to enhance the images, along with captions clarifying their contexts.

Alaska's archives have done a remarkable job of preserving the heritage of our state. Without the vast collections of the Alaska State Library, the University of Alaska Anchorage, the Anchorage Museum at Rasmuson Center, the Seward Community Library, the Anchorage Loussac Library, and the University of Alaska Fairbanks, this project would have been nothing more than a good idea.

Many thanks go to the librarians at each of these institutions—especially for their digitization efforts, which made combing through over 25,000 images substantially easier—and to all who donated collections that bring life to history and history to life.

Only the clearest and most compelling photos made the cut. Despite efforts to gather detailed information about each image, precise dates and identifications were not always available.

Because their contributions underlie all of Alaskan history, the first chapter pays tribute to Alaskan natives. Wherever possible, they are identified by their specific cultural groups as opposed to the more generic "Indian" or "Eskimo." Rich in oral traditions but often misunderstood and misrepresented by those who wrote things down, they had little chance to speak for themselves during much of the period covered here.

A bit of the Yukon slipped into the book with the gold rush. Our Klondike connections run deep, and it would be silly to let an arbitrary border keep us from acknowledging them.

From the first Alaskans through three eras of history to a culminating celebration of the land, enjoy this pictorial journey through the "magical territory," Alaska.

In spite of the overwhelming problems imperiling Alaska Native societies, their cultures remain vibrant. Their language and cultures have persisted, although changed, despite decades of governmental pressure to assimilate them into the larger society and the extensive forces of sociological impacts impinging on their communities. They are among the last societies in North America, who remain largely dependent and culturally attached to a hunting and gathering way of life . . . for the United States, they represent a rich cultural resource that is worthy of protection.

—ROSITA WORL, 2002

FIRST ALASKANS

According to legend, this has been their home since time began. Scientists long held that the first Alaskans' ancestors migrated across the Bering Land Bridge 10,000 to 12,000 years ago, spreading through North America and into Greenland. New evidence points to earlier coastal migrations as well.

The roots of these first Alaskans run deep: Haida, Tlingit, and Tsimshian along the southeastern coast; Eyak and Athabascan in Southcentral and the Interior; Aleut on the islands; Yupik, Cupik, and Inupiaq along the western and northern tundra. Though diverse in language and culture, they share bonds of grace, balance, and tenacious survival.

Waves of exploration and settlement disrupted their lives. Russian traders enslaved the Aleut. Disease ravaged villages. Missionaries forbade the work of shamans. Teachers prohibited native languages.

Well into the twentieth century, cultural bias prevailed. Early tourists breezed in and out of villages, penning tomes that made natives out to be curiosities at best, heathens at worst. Only later came a gradual understanding of the complex technologies, intricate art, and steadfast values that sustained these first Alaskans in a stunning but harsh land.

Forced from their nomadic way of life, subsistence remains the lifeblood of Alaska's natives. Through regional and local corporations formed under the 1971 Alaska Native Claims Settlement Act, they struggle to fend off forces that threaten their way of life—unhealthy foods, addictions, resource development, and an eroded sense of purpose—while balancing the realities of economic survival.

Woven throughout the history of Alaska, the stories of these first Alaskans are timeless. Traditions pervade and prevail. We celebrate them here, as the foundation of all that makes Alaska great.

. . . "Shamans" had always warned him against sitting for his picture, which, they averred, would be carried far away across the seas and probably be lost . . . destruction, body and soul, would surely and rapidly follow.

—HARRY DEWINDT, 1899

A Tlingit shaman wears the frog hat of his clan for this 1906 portrait. The Tlingit tribes extend along Alaska's Inside Passage north to Yakutat. Shamans were charged with healing, predicting the future, controlling weather, exposing evil, and communicating with the dead.

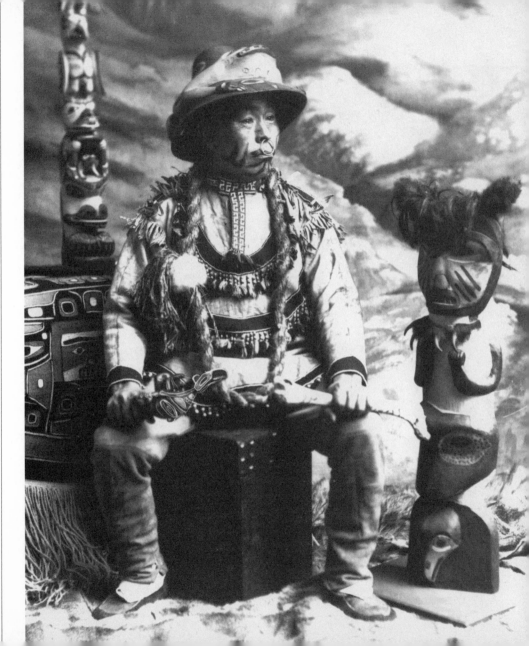

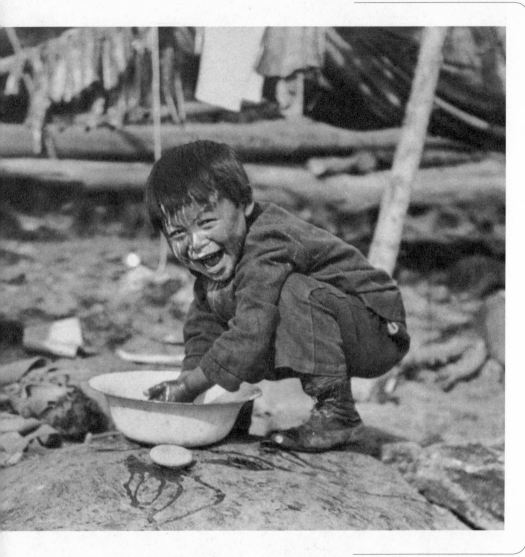

Soap, a metal washbasin, a washtub, clothing, and shoes indicate that this boy's family probably visited one of the many trading posts set up to serve miners in Interior Alaska in the early 1900s, when this photo was taken. Though forced to attend segregated schools and use separate hospitals, many Athabascans participated in the cash economy by working on riverboats or as guides.

Right: The notion that photographs could steal souls was apparently not a concern for these three Ahtna men posing for a studio portrait in the early twentieth century. The man in the middle is identified as Chief Goodletaw. Semi-nomadic prior to European arrival, the Ahtna traveled the Wrangell Mountains and the Copper River. Today they live alongside the Eyak and Tlingit in some of their original villages.

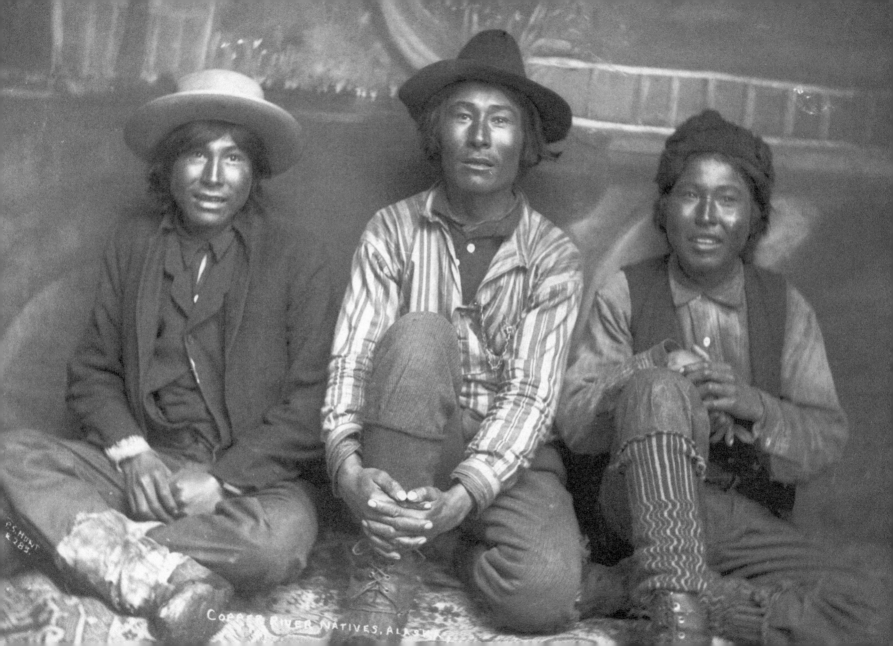

COPPER RIVER NATIVES, ALASKA

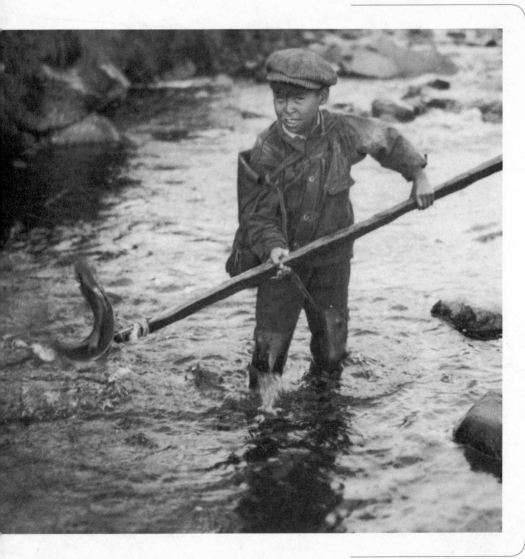

Rhoda Thomas, a teacher for the Bureau of Indian Affairs, captured this image of a boy spearing a fish on Attu Island in 1939. On the Aleutian Chain, Attu is so far west that it's actually in the eastern hemisphere. Today, except for a small U.S. Coast Guard contingent, the island is uninhabited.

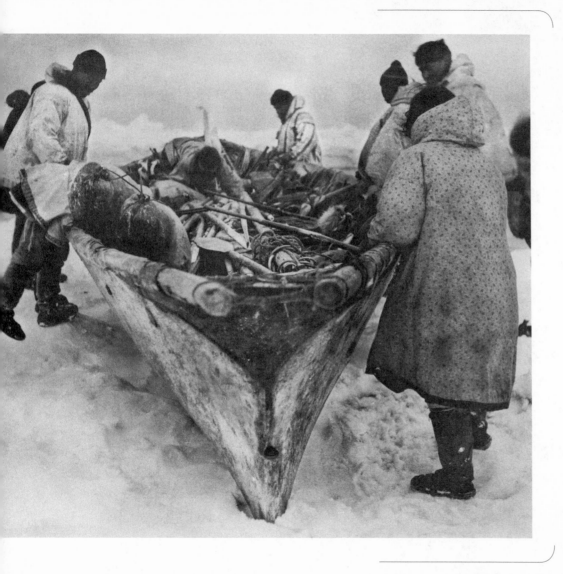

A boat was launched and filled, and came rapidly to the ship's side. It was made of walrus skin stretched over a wooden frame, and was a strong, shapely craft.

—JOHN BURROUGHS, 1904

Captured in this early twentieth-century photo, the umiak—a flexible, exceptionally seaworthy open skin boat—was used by Inupiaq villagers in Northern Alaska for walrus and whale hunting. Carrying loads of more than 2,000 pounds, the umiak were also used as temporary homes and ceremonial centers, and they are still used for hunting today.

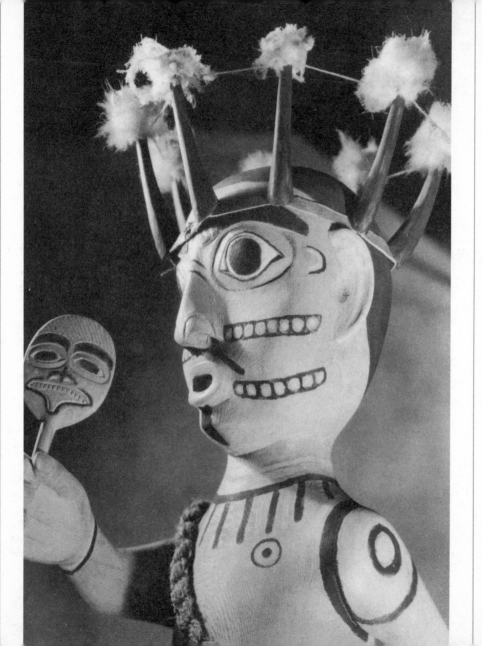

Tradition is something that most people say is identity.

—NATHAN JACKSON, TLINGIT WOOD-CARVER, 1995

Attributed to Ordway's Photo Shop in Juneau, this close-up of a wooden figure was probably taken in the 1930s, when Frederick Ordway, "Alaska's Flying Photographer," traveled and snapped photos across the territory. In Southeast Alaska, carved figures with strong black and red lines reflected dichotomies inherent in the clan-based cultures of the Tlingit, Haida, and Tsimshian.

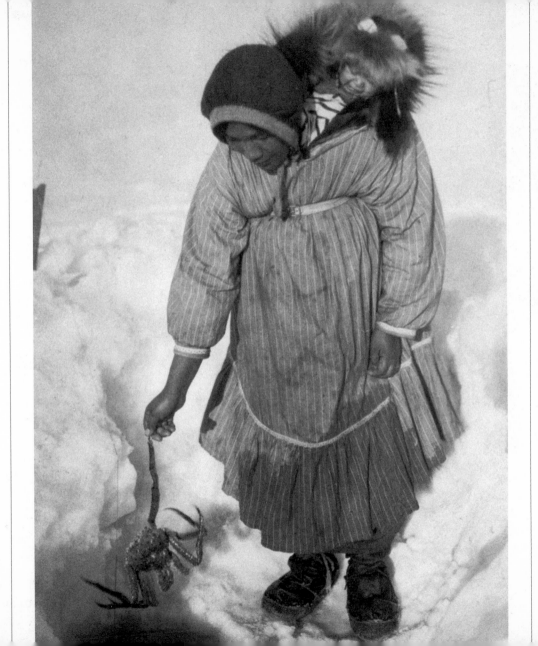

Wearing a kuspuk, parka, and mukluks she made herself, this unidentified Inupiaq woman pulls a spider crab from beneath the ice. Babies were traditionally carried in the parka hood.

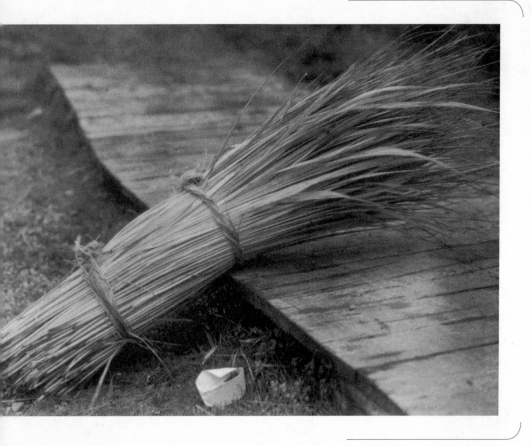

After sorting, the grass blades are gathered in neat bundles and hung out to cure. Whenever a rain shower came along all the curing grass bundles throughout the village were whisked out of sight as if by magic.

—OLAUS J. MURIE, CIRCA 1937, 90-03-1,
MURIE FAMILY PAPERS, ARCHIVES,
UNIVERSITY OF ALASKA FAIRBANKS

Margaret Murie documented the making of baskets on Attu Island in the Aleutians during the 1930s. Grass was cut twice a year, then buried in sand to hasten the bleaching process. Once bleached and dried, the grass was worked over an inverted container in tight weaves that could exceed 2,000 stitches per square inch.

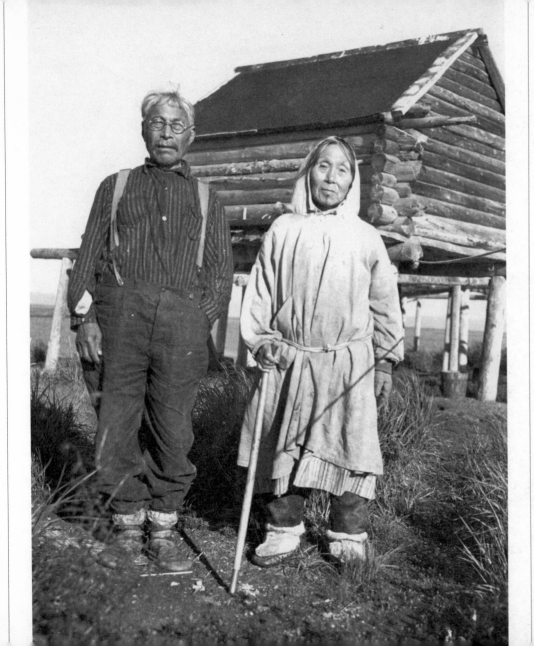

In an Alaskan version of Grant Wood's *American Gothic*, a man identified only as Mr. Niuqsik stands in front of a log cache in Shaktoolik with Ammak, his wife. Located on the Norton Sound approximately one hundred miles east of Nome, the village was moved from the mouth of the Shaktoolik River to its present, less storm-prone location in 1967. Due to climate change, Shaktoolik is once again threatened by erosion and flooding.

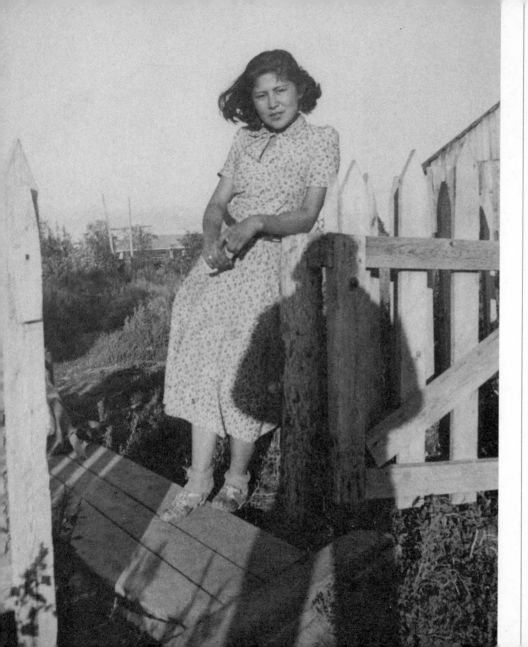

Fannie Wallis stands at a gate, possibly in the Athabascan village of Fort Yukon. Mother of Kay Wallis, spokesperson for the Gwich'yaa Gwich'in and former state representative, Fannie was originally from Old Crow, Yukon Territory. Relative Velma Wallis is the author of the award-winning books *Two Old Women* and *Raising Ourselves*.

It is difficult to get away from St. Michael, and even in summer you may have to wait a month or six weeks for a steamer . . . From its high, tundra-covered banks you have a fine view of the Bering Sea, and the grey gulls, as if matching the dominant grey, circle about one in a threatening manner, as if hungry, then fly screaming away to sea. It is a lonely place.

—CHARLOTTE CAMERON, 1920

A Yupik resident of Saint Michael chops wood from an abandoned steamship in this 1942 photo. Founded in 1833 as a Russian trading post, Saint Michael was once a regular stop along the Bering Sea route to Interior Alaska and the Klondike.

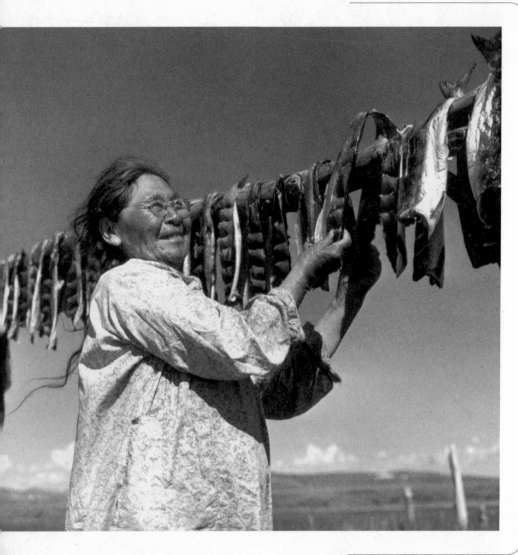

Summer in Alaska is a busy time of harvesting and setting aside food for the winter.

—U.S. FISH AND WILDLIFE SERVICE, ALASKA

Inupiaq Lucy Ben of Nome stands beside a rack of cut salmon hung to dry in this 1949 photo. Using an *uluaq* ("women's knife"), the Inupiaq cut the fish in half lengthwise, then crosswise in slats.

Right: From the 1950s, this photo shows Ruth Towksjhea in front of two sod houses in Point Hope, on the shore of the Chukchi Sea. In the winter, sod houses were insulated with dry grass beneath moss and sod. Summer homes were tents of caribou skins or temporary sod huts. Igloos were built only for temporary winter shelter.

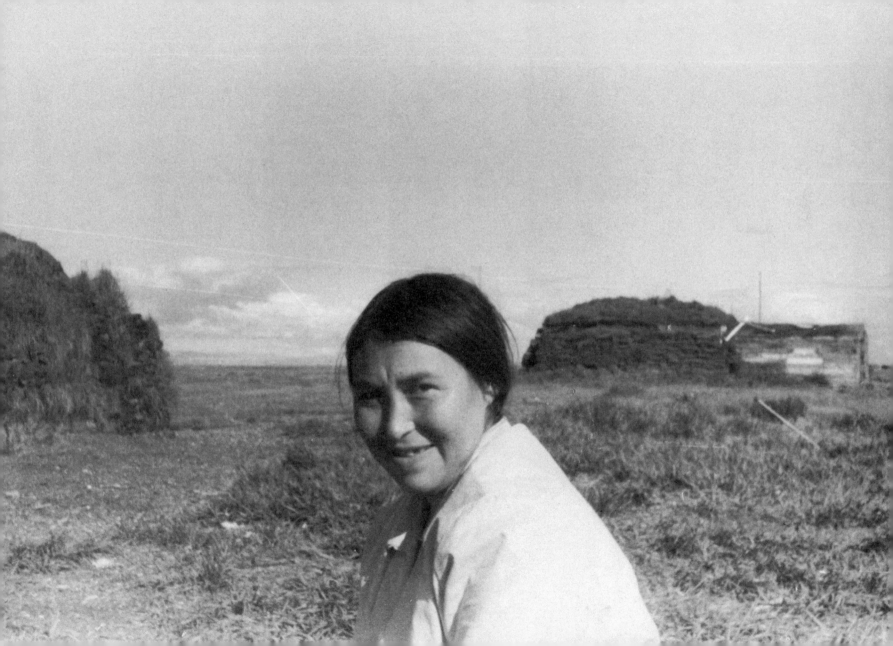

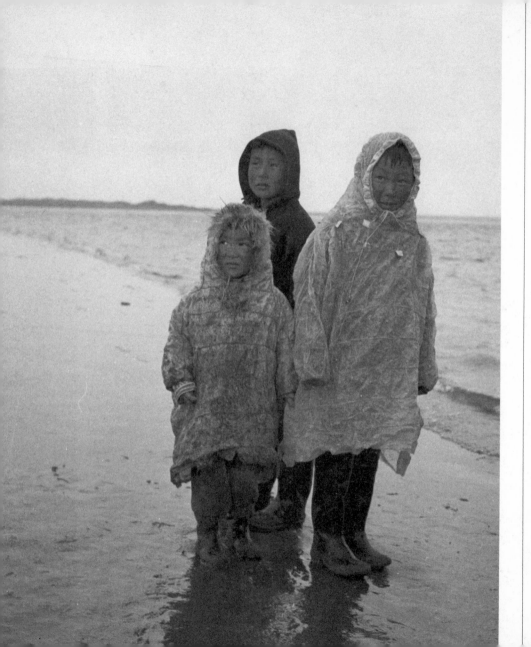

For wet weather, waterproof garments are made of seal gut sewed together in long strips. This waterproof coat is another Eskimo invention that deserves careful attention. It is worn over the furs, it weighs nothing, it has a hood attached and will not leak.

—GEORGE BYRON GORDON, 1917

Cupik children dressed in seal gut raincoats on the beach at Mekoryuk on Nunivak Island in the Bering Sea. Thirty miles west of the mainland, Nunivak is home to a small village, local herds of musk oxen and reindeer, and a variety of tundra plants, animals, and migratory birds. Cupik language and culture are closely tied to the Yupik.

An Alaskan still life, with teakettle suspended over a seal oil lamp in Gambell on Saint Lawrence Island. Populated primarily by Siberian Yupiks, the island lies thirty-six miles east of Russia's Chukchi Peninsula. Seal oil was a primary source of heat as well as light before electricity arrived.

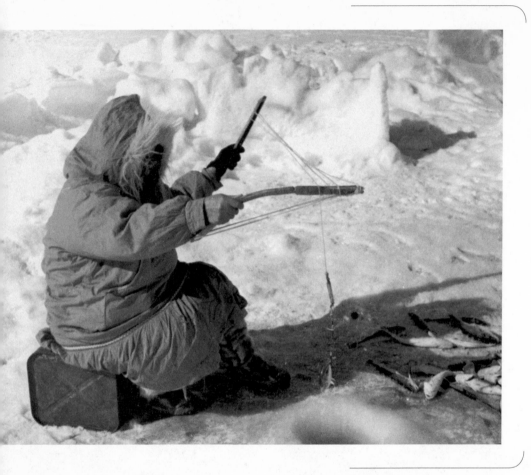

It has often been said that subsistence cannot be defined, and Alaska natives generally describe it as a "way of life."

—ROSITA WORL, PHD, TESTIFYING BEFORE THE U.S. SENATE COMMITTEE ON INDIAN AFFAIRS, APRIL 17, 2002

An Inupiaq woman sits on a gas can while ice fishing. Whitefish, burbot, and pike are commonly caught by jigging with sticks and string, with success hinging more on the skill of the angler than on fancy tackle and gear.

Then elders moved to the center of the floor and danced from kneeling positions, moving their arms and torsos to describe songs about hunting, picking berries, or muskrats and beavers popping their heads above water. The audience encouraged them by shouting out "Chale!" (encore). The dancers repeated their movements with greater intensity to the quickening tempo of thunderous large round frame drums.

—FROM A NATIONAL ENDOWMENT FOR THE ARTS REPORT, DESCRIBING YUPIK DANCING IN SAINT MARY'S, ALASKA, 1992

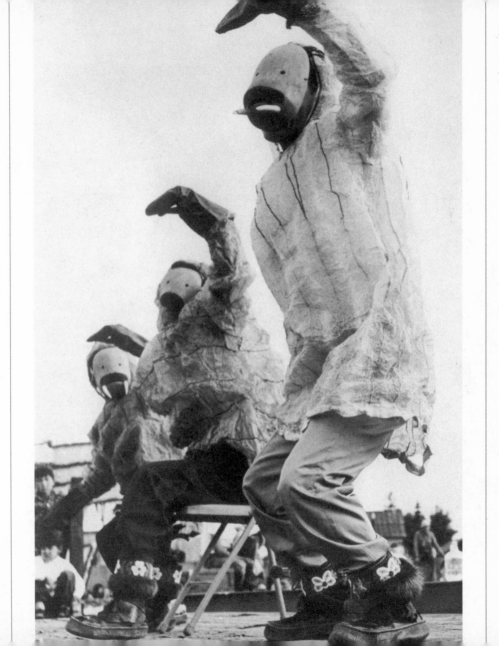

From Wien Air, founded by Alaska aviation pioneer Noel Wien, comes this undated photo of an Eskimo dance in Northern Alaska. Wearing masks with tusks and parkas made of waterproof walrus intestines, these Inupiaq dancers reenact a walrus hunt.

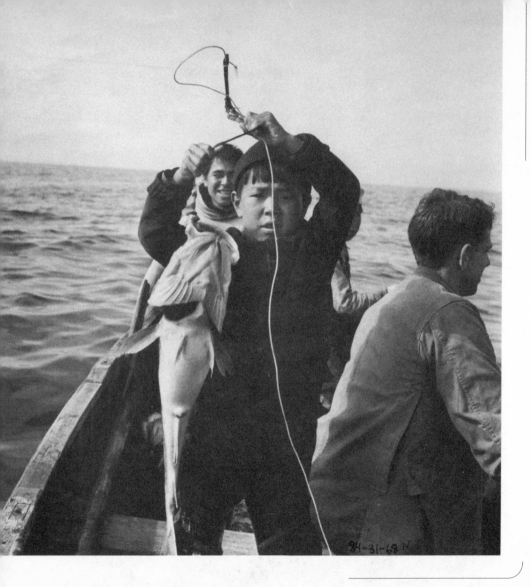

34-31-68

A Siberian Yupik boy from Saint Lawrence Island fishing in a wooden skiff shows off his catch to medical anthropologist Dorothea Leighton. Decimated by famine from 1878 to 1880, the population of Saint Lawrence Island dropped dramatically. Today, approximately 1,300 people live on the island.

Right: A hunter carries a caribou haunch near Anaktuvak Pass in the Brooks Range. For centuries, the people of Anaktuvak followed migrating caribou, but eventually they settled in a permanent village.

As for "why" the Inupiaq settled in the Pass, I got only the vaguest answers. Maybe the airstrip . . . maybe it was a central meeting point. But often the answer was, "I can't tell you." I wondered as they fought the cold and the children grew thinner for want of fresh meat; wondered until my last night in the Pass when the moon was as bright and full as an Inupiaq face and the mountains stood close around me in the awesome beauty of its light. Then, overwhelmed by the harsh grandeur, I stood alone on the hill by the school, not noticing the cold any more. Who would believe that man could survive to enjoy this place? And what a feeling of strength to know you can survive it, conquer it, live with it, feast off it—or even endure it!

—LAEL MORGAN, 1972, WITH CREDIT TO LAEL MORGAN, THE *TUNDRA TIMES*, AND THE ALICE PATTERSON FUND

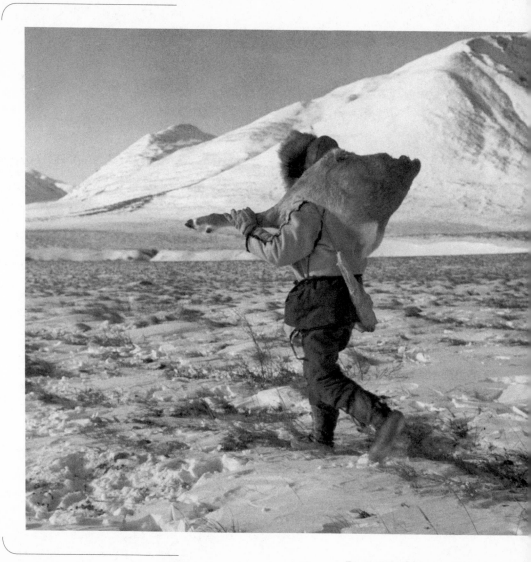

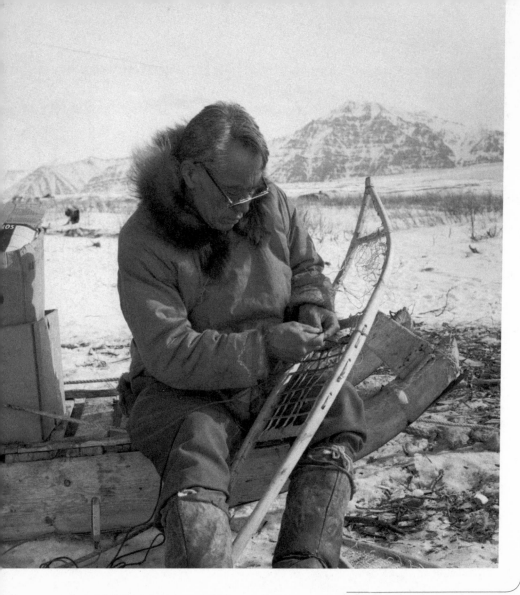

Seated on a wooden sled, Simon Paneak of Anaktuvak Pass mends snowshoes in this 1963 photo.

Right: A man cleans out his fish wheel in this image from the 1960s. Fish wheels were introduced by miners in the early 1900s and adopted by Athabascans to harvest salmon.

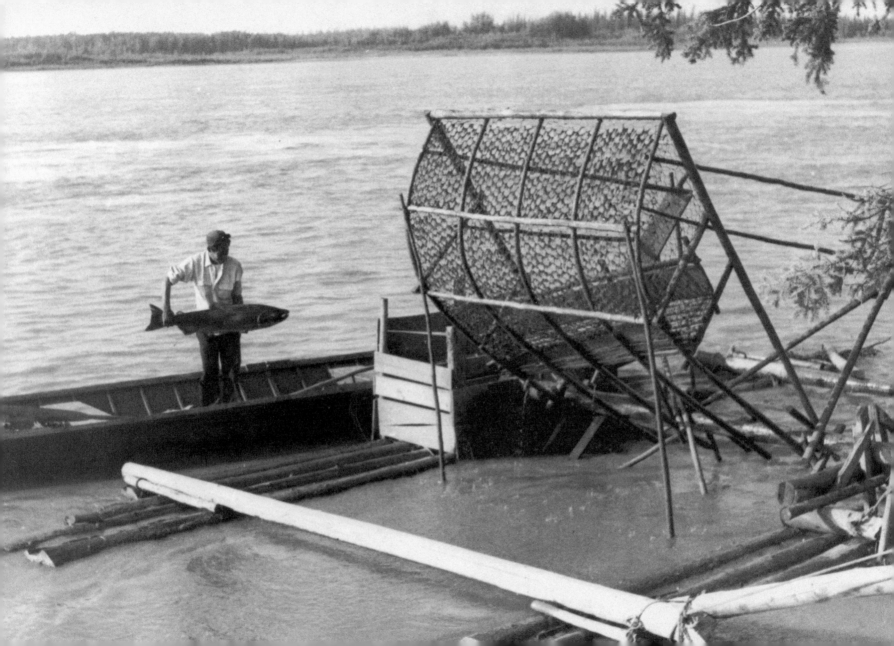

During the long winter months the men work here, making sleighs, snowshoes, dressing skins, sometimes making the parkas and mukluks. Here the women bring them their dinner: stewed caribou, ptarmigan, or Arctic hare (always the choicest morsels); with dried fish . . . and the indispensable tea.

—VOICE OF ALASKA, 1935

A Siberian Yupik community house, photographed in 1969 in Gambell on Saint Lawrence Island. Driftwood forms the walls and walrus skins cover the roof. In the foreground is a food cache, and to the left is a skin boat, or umiak, on a rack. In some Yupik communities, all males lived in the community house—the *qasgiq*. Women lived in a smaller communal dwelling and prepared food for all.

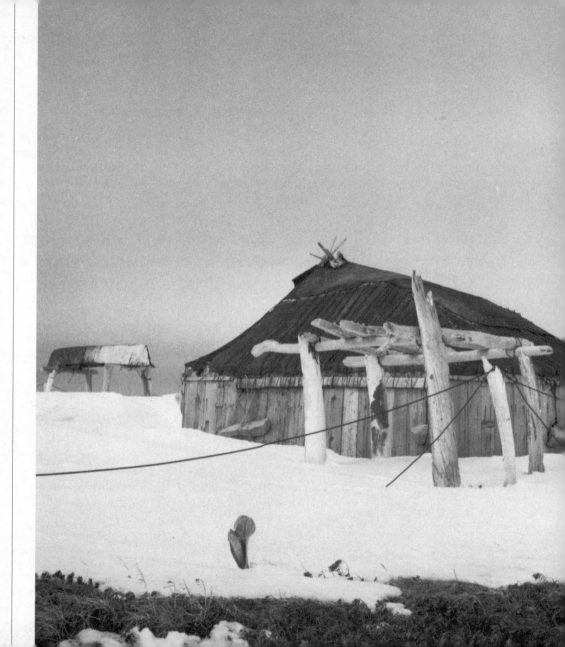

A Tlingit totem pole is transported along a board-walk in Southeast Alaska. Carved from cedar, totem poles originally portrayed family stories and accomplishments through clan crests. There were poles of greeting, mortuary poles, house-front poles, and even shame poles.

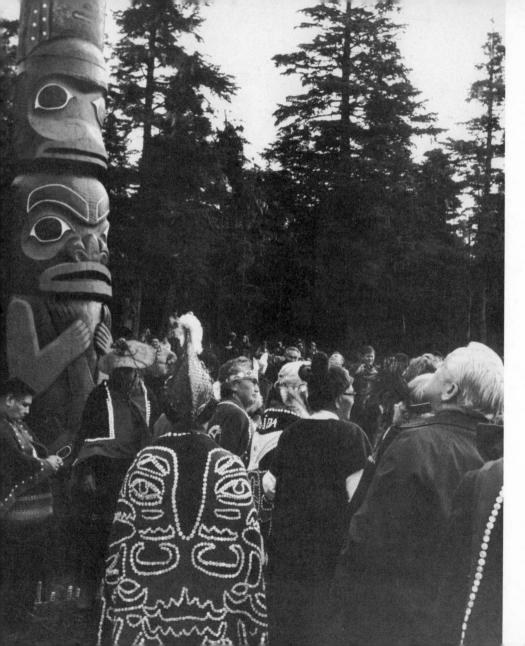

The whole work is serious in aspect and brave and true in execution.

—JOHN MUIR, UPON VIEWING TOTEM POLES, 1915

William Egan (right), first governor of the state of Alaska, joins Tlingit dancers admiring a 132-foot totem pole raised on a bluff overlooking the village of Kake in 1971. While totem poles disintegrated over time in the rain forests of Southeast Alaska, many of Kake's poles were burned in the 1920s. Alaska Indian Arts, Inc., of Haines carved this replacement pole.

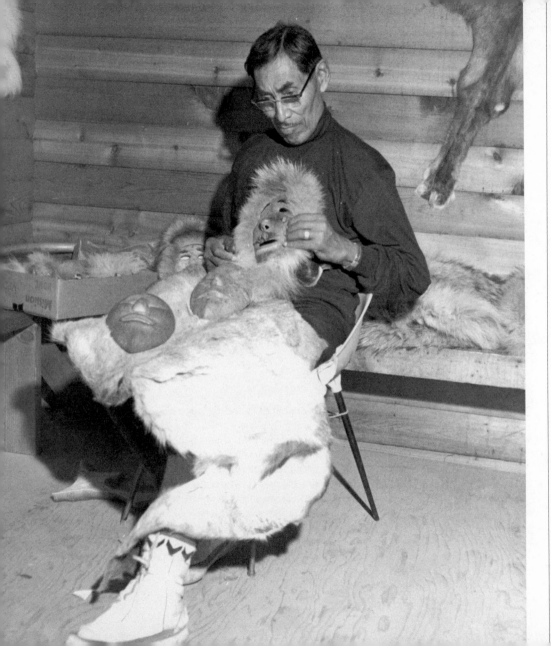

The influence of American Indians and Alaskan Natives on the culture of America is profound. Indian art, language, philosophy, and spirituality are woven into the fabric of our nation.

—CHARLES W. GRIM, UNDATED

Frank Rulland of the Brooks Range community of Anaktuvuk Pass makes masks from caribou hides in this 1969 photo. After scraping the hide, the mask-maker fits it over a wooden form, cuts the face, and adds a wolf ruff. Traditionally, masks made by Alaskan natives were symbolic reflections of stories, visions, or dreams. They were used by shamans and in dancing. The Anaktuvuk-style masks, however, were fashioned after Halloween masks and crafted primarily for sale.

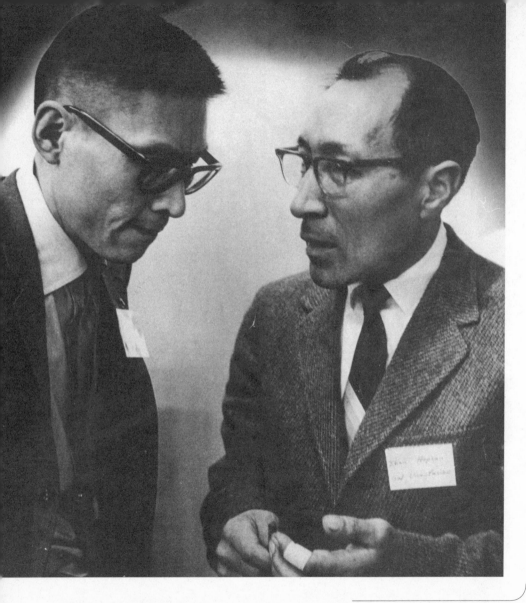

President of the Arctic Slope Native Association Joseph Upicksoun (left) and former State Senator Eben Hopson (right) confer at a 1970 meeting of the Alaska Native Brotherhood (ANB) Executive Committee. Founded in Sitka in 1912, the ANB was instrumental in securing citizenship, promoting education, preserving culture, and protecting native lands. Building on the advocacy efforts of the ANB, the Alaska Federation of Natives, founded in 1967, helped achieve passage of the Alaska Native Claims Settlement Act in 1971.

We are the ones who have every-thing to lose.

—SARAH JAMES, BOARD MEMBER/
SPOKESPERSON, NEET'SAI GWICH'IN, ARCTIC
VILLAGE, 2008

An Alaskan native competes in the 1974 Arctic Winter Games. Established by the governors of Yukon, Northwest Territories, and Alaska in 1970, the Arctic Winter Games promote competition, cultural exhibition, and social interaction among circumpolar athletes.

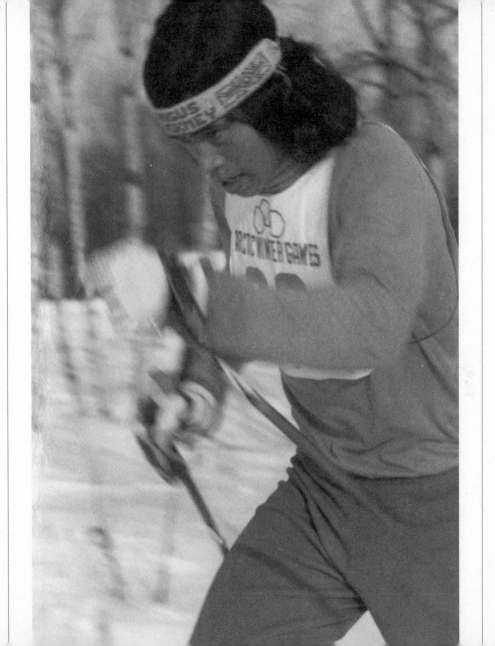

There are strange things done in the midnight sun by the men who moil for gold; the arctic trails have their secret tales that would make your blood run cold . . .

—ROBERT SERVICE, "THE CREMATION OF SAM MCGEE," 1907

RUSH TO GOLD: 1867–1913

Gold.

The frenzy of it shaped Alaska.

Prospectors primed by the mid-nineteenth-century rush to California trickled north to the territory known as "Seward's Folly," purchased from Russia in 1867, to work creeks around Juneau and in the Interior's Fortymile District. Then came the granddaddy of all strikes: the Klondike.

"Like cheese in a sandwich"—that's how Skookum Jim Mason, Dawson Charlie, and George Carmack described their find at Bonanza Creek, a tributary of the Yukon, in 1896. As news of the discovery spread, thousands flocked north.

The two best ways to the Klondike went through Alaska. Neither route was easy. The all-water passage, through the Bering Sea and up the Yukon River, required lots of time and money. It was cheaper to land at Skagway and trek over the Chilkoot Trail, the "meanest 33 miles in history."

Forty to fifty thousand stampeders reached Dawson only to find the claims already taken. Most returned home, but some followed subsequent rushes—to Nome in 1900, where an endless supply of gold was thought to wash up with every wave, and to Fairbanks in 1903.

With every rush, tent cities sprang up. Hoteliers, retailers, blacksmiths, and washwomen set up shop. For every would-be miner trained on gold, dozens discovered not shiny metal but opportunity.

By 1910, the frenzy was over. Alaska's population had surged to 60,000. Most of the boomtowns folded, but some took root and prospered. Businesses and government agencies began looking north, where other minerals and fisheries promised continuing wealth. Road systems expanded, and citizens of the Alaska Territory achieved limited rights to local government along with a delegate to Congress.

Trails to gold forged pathways to the future.

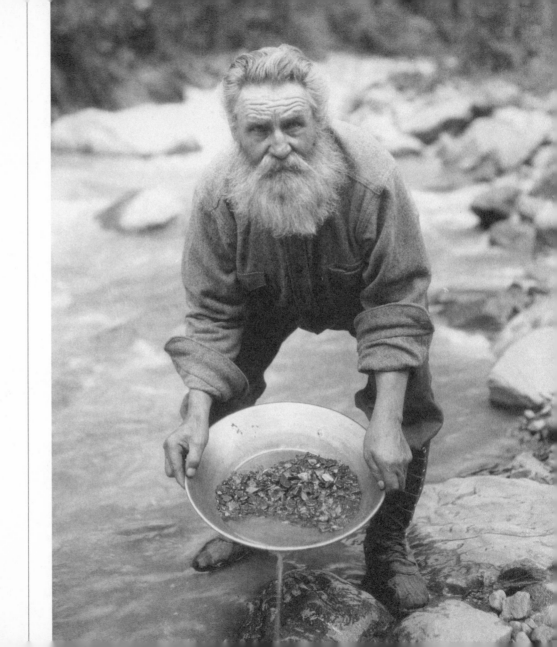

A man identified as "Two-Step" Jake Hirsch pans for gold in this photo by Leonard Delano. Gold panners dip rock and water from a stream, then swish to extract gravel, leaving heavier gold at the bottom of the pan.

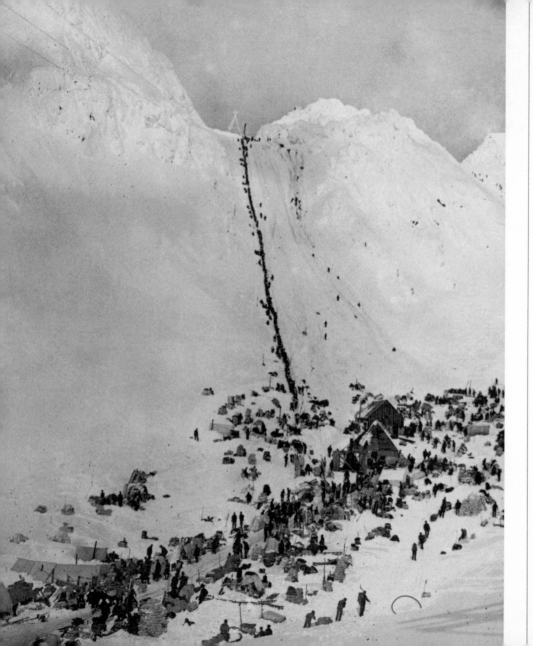

It is here where many people give up the struggle and turn back. At times, the trail is full of men with sore backs and feet, lying on the snow in utter despair. Many even weep with disappointment.

—WILLIAM M. STANLEY, 1898

In this 1898 photo, hundreds of prospectors climb the Scales, a bowl of snow-covered boulders in the Chilkoot Pass. Because the Canadian government required prospectors to have a full ton of supplies, each made twenty to forty trips over the pass. The Chilkoot Trail begins in Dyea, Alaska, and ends at Lake Bennett in the Yukon Territory.

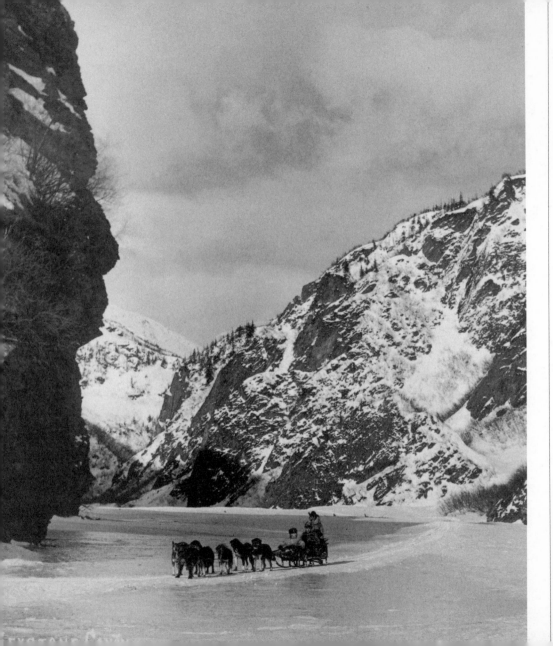

Dogs pull a sled across the ice at the entrance to Keystone Canyon near Valdez in this 1899 photo. More than 4,000 stampeders rushed to Valdez in 1898 when steamship companies hinted at vast quantities of gold along the Copper River in what proved to be a grand hoax. Eventually an ice-free trail from the coast to the Interior was built to replace the treacherous Valdez Glacier Trail.

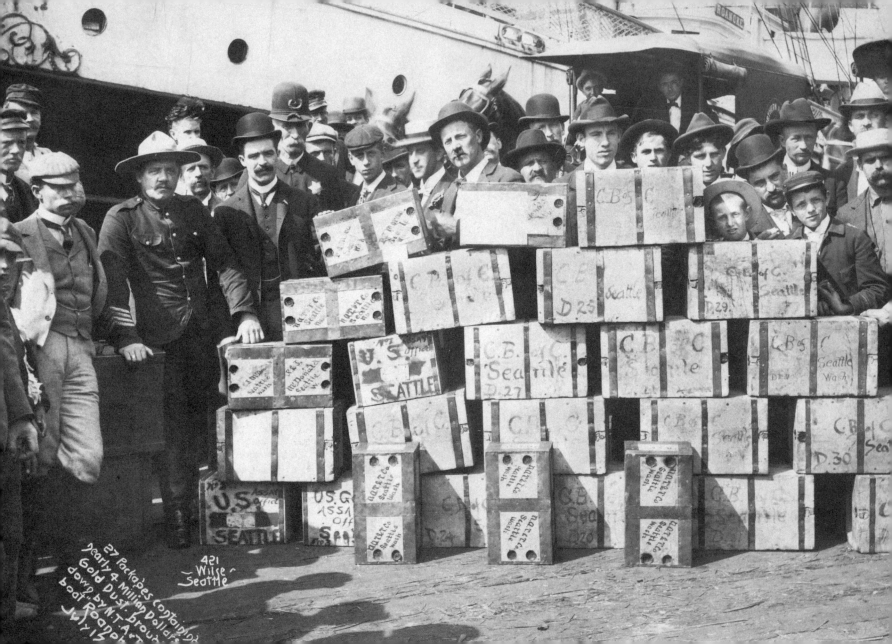

421
Wilse
Seattle

27 Packages Containing
Nearly 4 Million Dollars
Gold Dust Brought
down by N.T.A.Co
boat "Roanoke"
July 15

Arctic Gold. What I have seen it do. It's tragedy not finding it; it's sometimes ten times worse when found.

—JOSEPH CRAD, 1900

Left: The notation on this 1899 photo by Seattle photographer Anders Wilse says these men are posing with "27 packages containing nearly 4 million dollars in gold dust, brought down by N.T.A. & T. Co. boat 'Roanoke.'" Thousands of prospectors journeyed from Seattle through Alaska to access the Klondike, said to yield—in some spots—$800 worth of gold per shovelful.

The grave of con man Jefferson R. Smith, known as Soapy from a scam involving $10 bars of soap, who died in a gunfight with Frank Reid on July 8, 1898. Soapy and his gang terrorized the gold rush town of Skagway until a mob rose up against them, and Reid sacrificed his own life to rid the community of its unsavory leader.

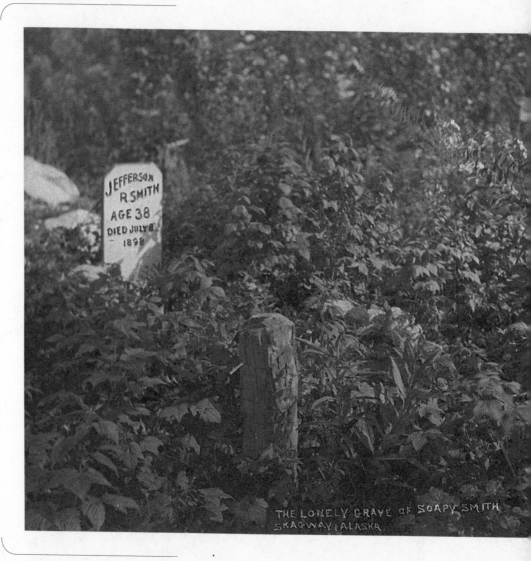

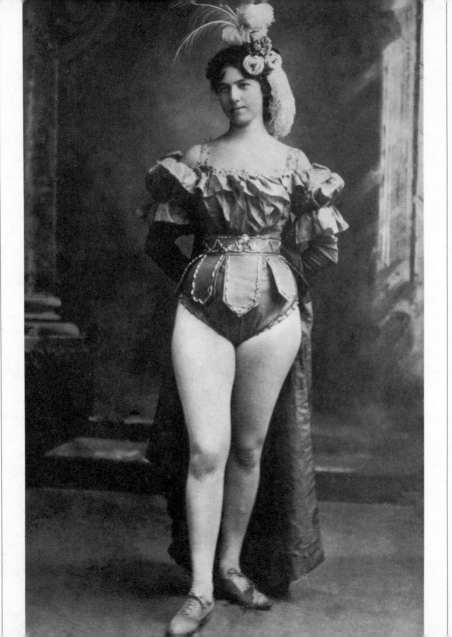

The "ladies of adventure" made lots of money at Dawson; some of them "cleaned up" from $25,000 to $100,000. They got an interest in claims with the diggers and even married them.

—T. A. RICKARD, 1909

A portrait of Kate Rockwell, better known as Klondike Kate. Kate made her way to Skagway and then to Dawson in 1899, the year this picture was taken. She worked as a dance hall girl, bragging that she once earned $750 in one night just for talking to lonesome miners.

Right: This 1899 photo shows four women, probably prostitutes, on a boardwalk in Klondike City, also known as Lousetown. When prostitution became illegal within the city limits of Dawson, the trade moved across the river to Klondike City, where the red-light district grew to sixty tiny frame houses, or "cribs."

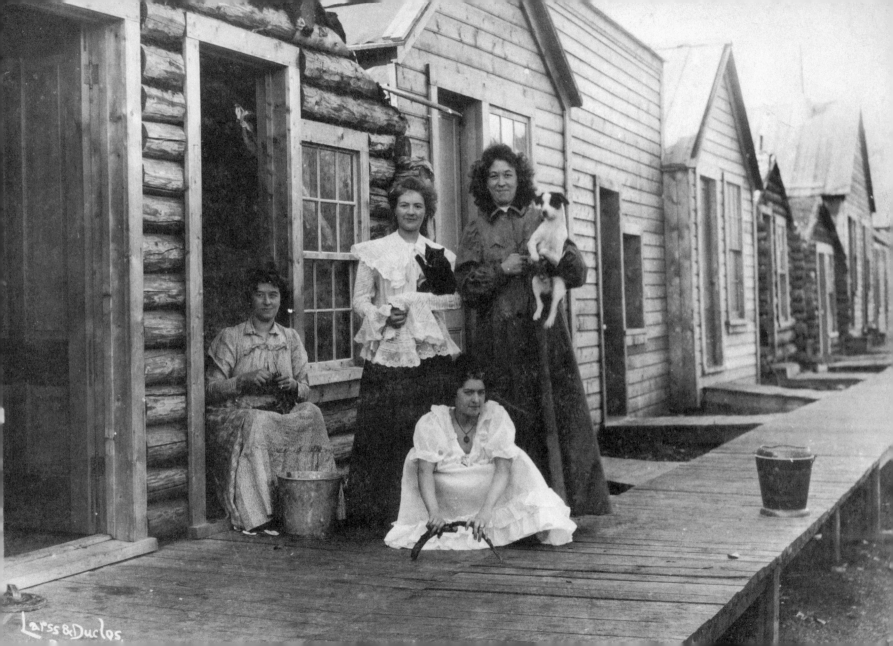

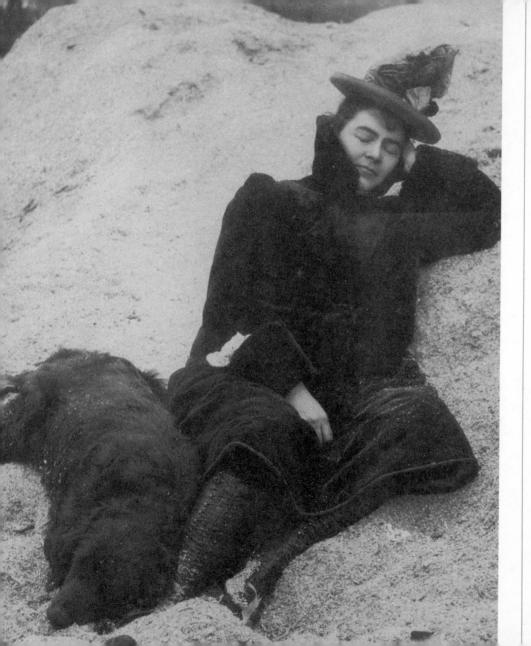

In this 1900 photo titled "Exhausted Stampeder,"
Maud Earl and a dog lie in a mound of sawdust.

I wanted the gold, and I sought it; I scrabbled and mucked like a slave. Was it famine or scurvy—I fought it; I hurled my youth into a grave. I wanted the gold, and I got it—Came out with a fortune last fall. Yet somehow life's not what I thought it, and somehow the gold isn't all.

—ROBERT SERVICE, *THE SPELL OF THE YUKON*, 1907

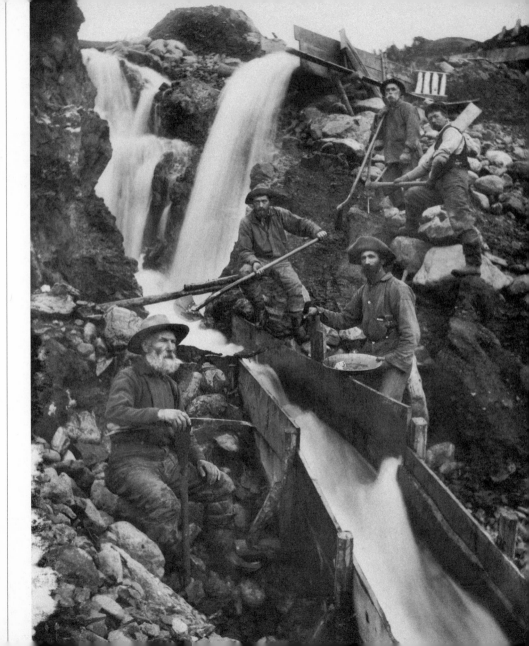

A miner displays a huge nugget in this photo from the early 1900s. Gold mining operations used great quantities of water. In the Tanana Valley goldfields, the ninety-mile-long Davidson Ditch transported water from the Chatanika River.

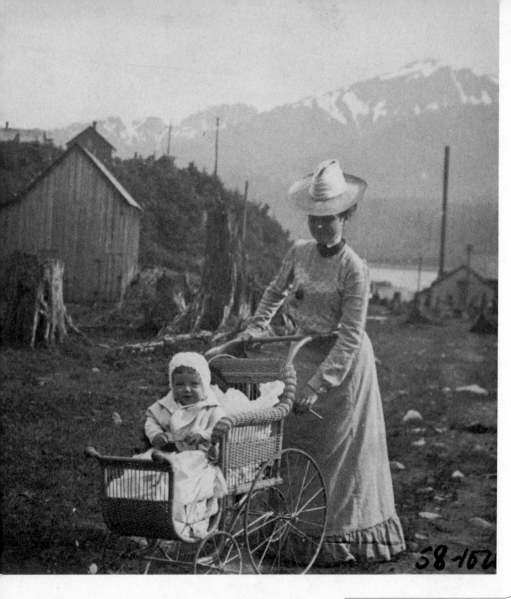

As for adventure—that is relative. Where little happens and the gamut of expression is narrow life is still full of joy and sorrow. You're stirred by simple happenings in a quiet world.

—ROCKWELL KENT, 1920

A pioneer woman with her baby carriage in the early 1900s. Though not in equal numbers with men, women flocked to the North during the gold rush era, following their husbands or determined to earn their own fortunes by working claims or plying trades.

Right: Not all was toil and hardship in the early days of prospecting. In this photo taken in the early 1900s, a group enjoys the winter fun of tobogganing.

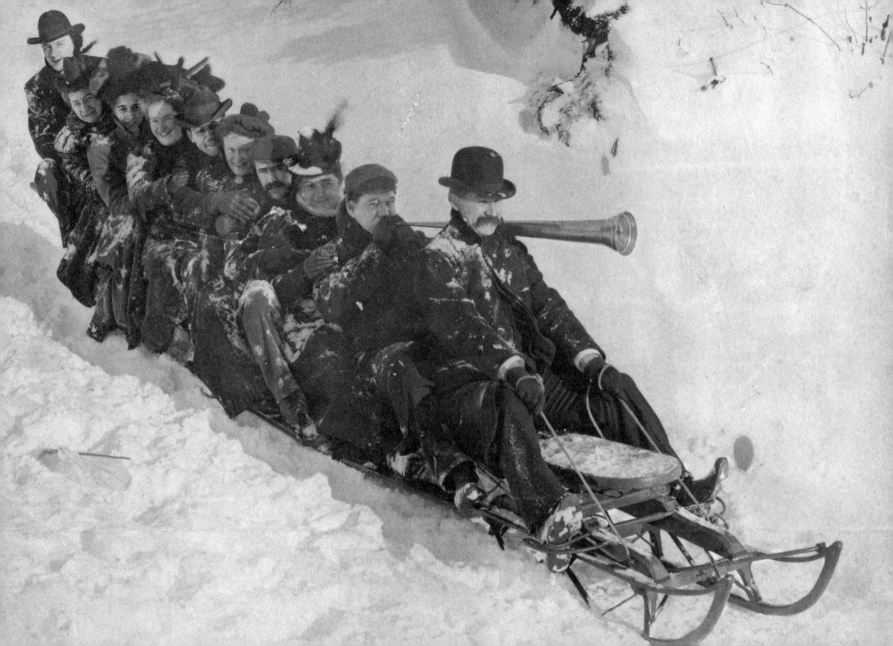

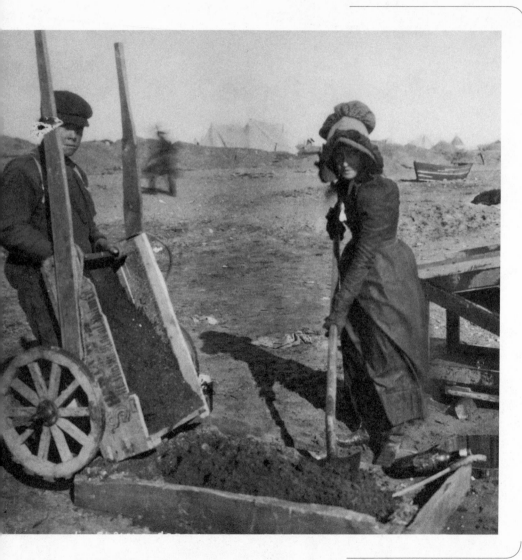

The spirit of Nome is restless; it is the spirit of the gold-seeker, the seafarer, the victim of wanderlust; and it soon gets into even the visitor's blood . . . New strikes are constantly being made, to keep the people of Nome in a state of feverish excitement and dynamic energy.

—ELLA HIGGINSON, 1923

Working the "golden sands" on the beach of Nome. "Three lucky Swedes" made the first strike at Anvil Creek in September of 1898. Two years later, the tent city of Nome had swelled to a population of 20,000.

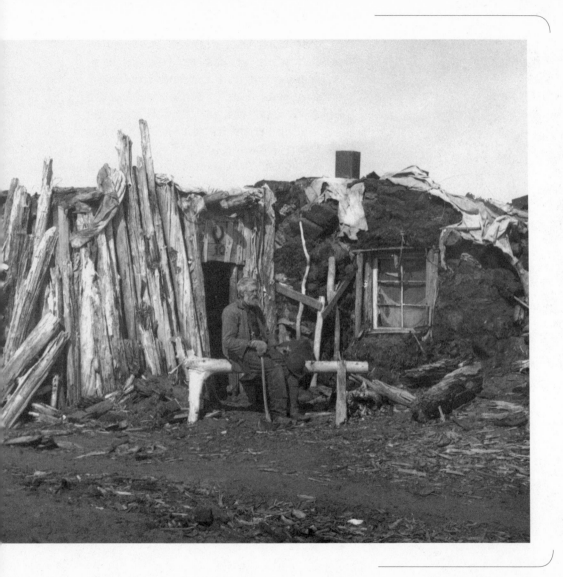

This 1905 photo shows a miner's cabin built of driftwood and sod on the beach at Nome. Nome was more accessible than the Klondike, but survival was harder due to the lack of trees for shelter and heat. Lawlessness coupled with corruption compounded the problems for fortune-seekers. By 1910, the rush was over.

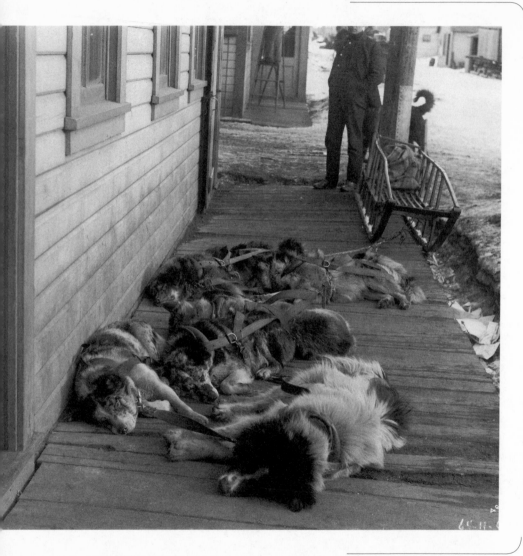

The trail was marked every winter with stakes or branches of trees where it crossed the river, and was thus kept flagged by the mail-carriers, who made regular weekly trips in relays both ways from Dawson, via Eagle, Circle, and Fort Yukon, to Fort Gibbon at the mouth of the Tanana River, and thence to Nome, a distance from Dawson of sixteen hundred miles.

—JAMES WICKERSHAM, 1938

The notation on this 1905 photo taken in Nome says "mail team's break time." In the winter, dog teams ran mail and supplies from Interior Alaska to the Seward Peninsula.

In this photo taken in Barrow between 1899 and 1908, an unidentified man stands beside strips of baleen that have been cleaned and stacked for shipment to the Lower 48. A whaling station was established in Barrow at the end of the nineteenth century, when baleen—feeding plates from inside the mouths of whales—was coveted for use in corsets and parasols.

. . . Between the seasons, when travel on the rivers is positively dangerous to life, the mail must still be dispatched and received, although so great is the known risk to the mail, as well as to the carrier, that no one will send any letter that he cares at all about reaching its destination until the trails are established or the steamboats run.

—HUDSON STUCK, 1914

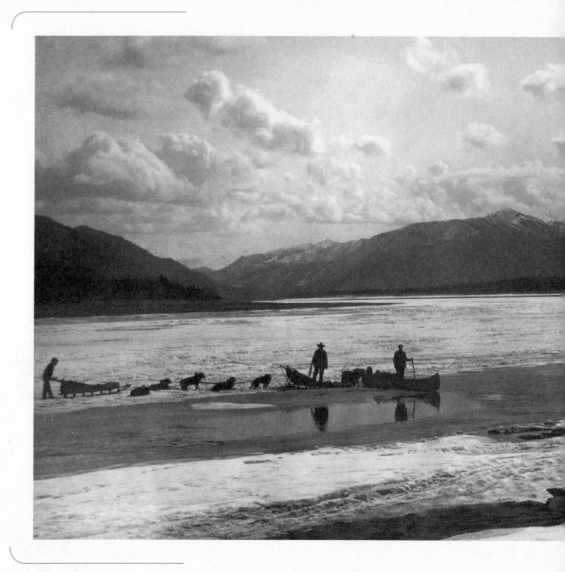

A dog team runs the mail to Eagle in this 1906 photo titled "Last Mail up Yukon River." Standing water is a sure sign of impending breakup, when river ice thaws in the spring.

A notation identifies this 1906 photo as the D. T. Kennedy Pack Train, carrying more than 1,200 pounds of gold dust for the First National Bank of Fairbanks. Though the river is unidentified, it may be the Chena, where the bridge went out every spring, necessitating the type of cable crossing shown here.

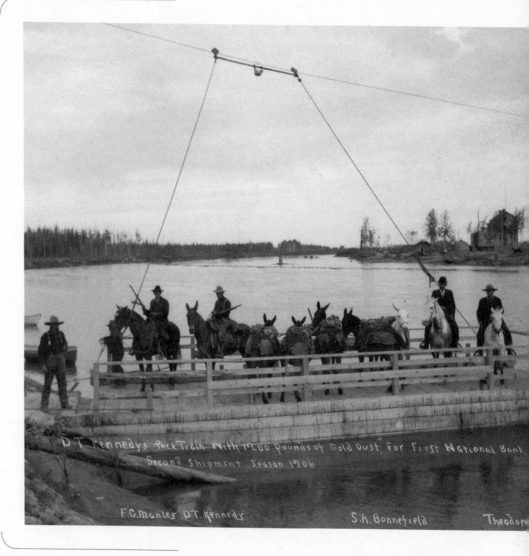

D.T. Kennedy's Pack Train With 1200 Pounds of Gold Dust For First National Bank Second Shipment Season 1906

F.G. Manley D.T. Kennedy S.A. Bonnefield Theodore

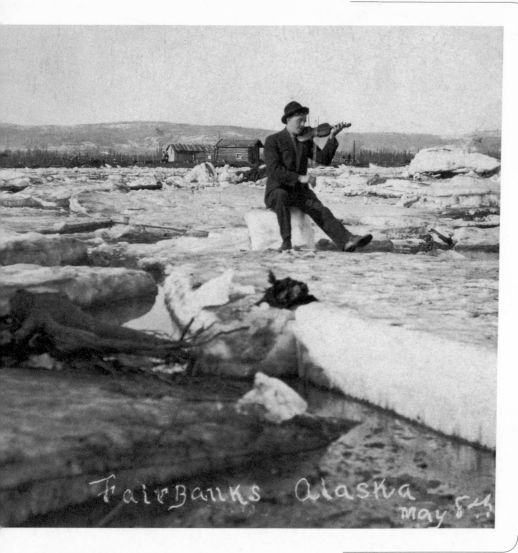

Fairbanks Alaska — may 5 ч

The Fairbanks Miner: Published occasionally at Fairbanks, Alaska, by a stampeder who is waiting for the snow to melt and the ice to go out of the rivers.

—JAMES WICKERSHAM, *THE FAIRBANKS MINOR*, VOL. 1, #1, MAY 1903

In this photo dated May 5, 1911, an unnamed violinist perches on the shifting ice of the Chena River. Ten years earlier, in August of 1901, E. T. Barnette was headed 400 miles up the Tanana River to establish a trading post when his chartered stern-wheeler, the *Lavelle Young*, went aground in approximately this spot, seven miles above the mouth of the Chena. Thanks to the gold strike of miner Felix Pedro, the shady businessman was able to set up shop right where he'd landed, and the town of Fairbanks was born. By 1912, Fairbanks had two hospitals, two daily newspapers, twelve hotels, and a telegraph line to the outside world.

Taken prior to 1913, this photo of Carlson Creek Canyon near Juneau was originally part of a collection belonging to the Alaska Juneau Gold Mining Company. Miners flocked to Juneau when placer deposits were discovered there in 1880. Though the placer gold supply was quickly diminished, hard-rock deposits—requiring more substantial investments to mine—kept Juneau on the map. Rushing waters like those of Carlson Creek provided cheap hydropower for mining operations.

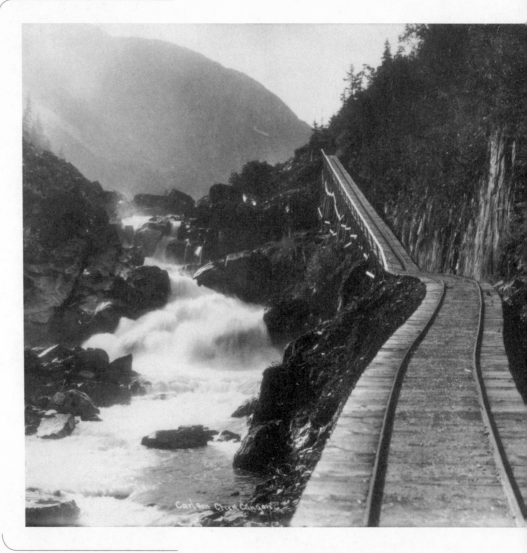

Carlson Creek Canyon

The appetite a man has on the trail is astonishing.

—J. D. FRASER, 1923

In this photo from the early 1900s, telegraph lineman E. R. McFarland broils a rabbit for lunch. In 1904, the Washington Alaska Military Cable and Telegraph System (WAMCATS) laid the first cable to connect Alaska with the Outside; in 1905, the first telegraph was sent from Fairbanks to Valdez.

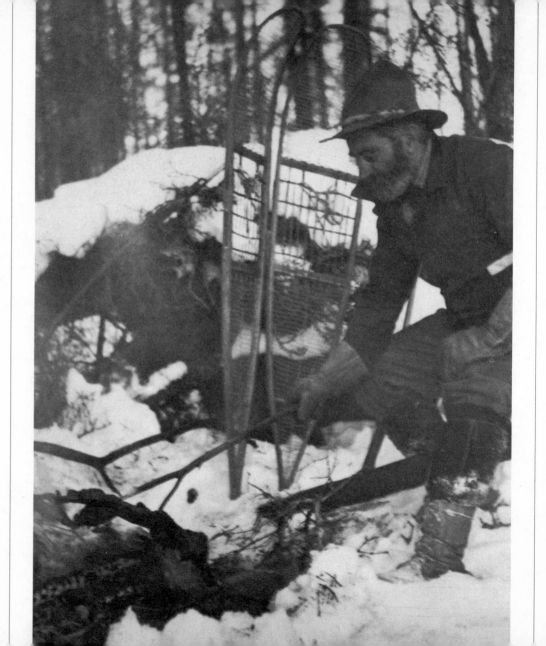

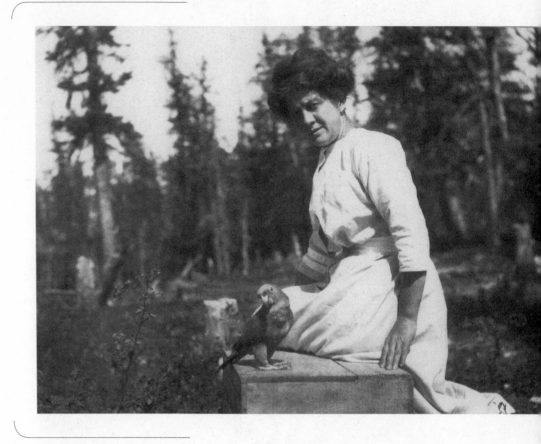

In a tent camp near Seward, an unidentified woman poses with her parrot, circa 1910. Named for the man who orchestrated the 1867 purchase of Alaska from Russia, Seward began as a settlement of prospectors and was organized into a railroad town in 1903 to connect the rest of the territory with Seward's ice-free harbor.

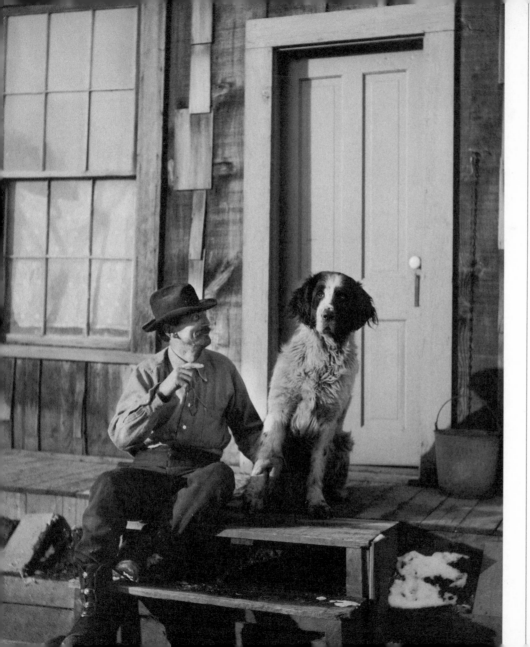

Your dog is a true pal. Treat him as such.

—JOSEPH CRAD, 1900

An unidentified man sits with his dog for this early twentieth-century photograph by P. S. Hunt. Dogs provided not only transportation but also companionship for Alaska's early settlers.

By land or by sea: The U.S. Revenue Cutter *Bear*, photographed with a dogsled team in Northwest Alaska between 1908 and 1934. Originally a whaler, the *Bear* was purchased by the U.S. Navy in 1884 to aid in the rescue of the ill-fated Greely Arctic Expedition. Reinforced to break through thin ice, the *Bear* served forty years as a revenue cutter in Alaska before the navy reacquired the ship, which ultimately sank in 1963.

We are Alaskans. We are neither demi-gods nor demons, but human folk with human foibles, very human cares. Yet there is something great in the land's self, that tempts men to a greatness in themselves here. This is the inner secret of our love for her, that in her devious way, some time or other, she has been generous in giving us our chance to do a bigger or a better thing than we had done before, or guessed we could do. Often we fall far short of all she asks us, yet most of us have cause to love and thank her for her constant testing assay. We are Alaskans, and Alaska still remains The Land Where Anything Might Happen.

—MARY LEE DAVIS, 1931

GROWTH AND EXPANSION: 1913–1938

Opportunity. "Seward's Folly" had "proven up," as miners would say, on gold. What other riches did the country hold?

Plenty, according to those who lauded America's most vast and isolated territory. How best to develop and protect those resources became a matter of some concern. Canadians poached seals in the Bering Sea. Coal mining required regulation. Fisheries demanded protection. In the early decades of the twentieth century, Congress struggled with these and other issues in the fledgling territory.

While Alaska's bounty stole much of the limelight, early naturalists like John Muir celebrated the territory's beauty. The efforts of naturalist Charles Sheldon and mountaineer Harry Karstens culminated in 1917 legislation establishing Mount McKinley National Park, later renamed Denali National Park and Preserve.

Completed in 1923, the $65 million Alaska Railroad heralded progress while contributing to the demise of steamboat traffic on the Yukon. Aviation brought even greater change by connecting communities flung far from Alaska's mere 2,500 miles of road. By 1937, the territory boasted ninety-seven civilian airfields, with more than one hundred times more planes per capita than in the Lower 48 states. The U.S. Post Office began phasing out the use of dog teams to deliver mail.

During the Great Depression, Alaska shined a beacon of hope for those who could afford to get there, just as it had during the 1890s depression. Under the New Deal, President Franklin D. Roosevelt established the moderately successful Matanuska Valley Colony by transplanting 201 families from the Upper Midwest to develop agriculture north of Anchorage.

As promise stacked up in the territory, residents demanded a greater say in their own affairs. In 1916, Alaska's lone congressional delegate, James Wickersham, introduced the first of many statehood bills, formalizing a movement that would take more than forty years to achieve its goal.

A self-portrait of George A. Parks (1883–1984), with pack and rifle, taken at Homer. Parks came to Alaska as a mapmaker in 1907 and helped lay out the city of Anchorage as assistant supervisor of surveys in the early 1920s. In 1925, President Calvin Coolidge appointed him territorial governor of Alaska, a post he held until 1933. In 1975, the highway linking Fairbanks and Anchorage was renamed in his honor.

No route exists that equals the grandeur and beauty of the scenery found on the trail from Valdez through the valley of the Copper to the Tanana River, Alaska . . . Precipices—perpendicular walls reaching to astonishing and dizzy heights, where the eaglet is taught his first lesson—loom up before you.

—ADDISON M. POWELL, IN A REPORT TO CAPTAIN W. R. ABERCROMBIE, 1900

The original Fairbanks—Valdez road, with mountains in the background. The trail from the ice-free port of Valdez to the gold rush town of Fairbanks became a wagon road in 1905. Twice a month in the winter, horse-drawn stages transported gold along the road to ships waiting in Valdez. Roadhouses sprang up along the route, which eventually became the Richardson Highway.

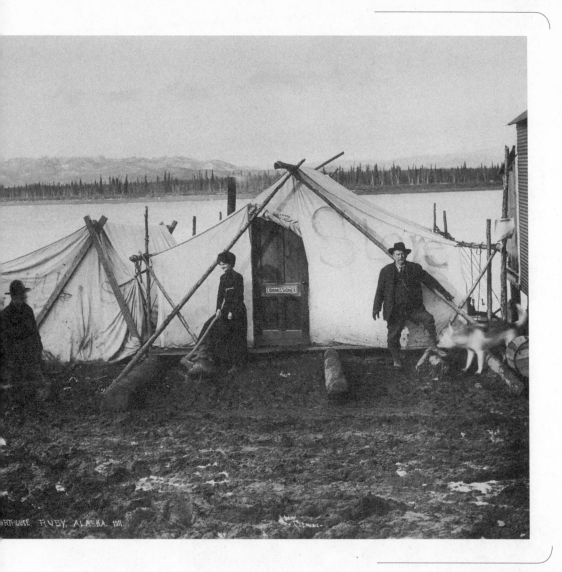

COMMISSIONER

CARTHOUSE. RUBY, ALASKA. 1911.

The courthouse at Ruby in 1911—the year the town was founded—with the Yukon River in the background and an ample supply of mud in the foreground. Frontier justice began with informal miners' courts, but after passage of the 1884 Organic Act, federal appointees held court in remote and sometimes primitive settings.

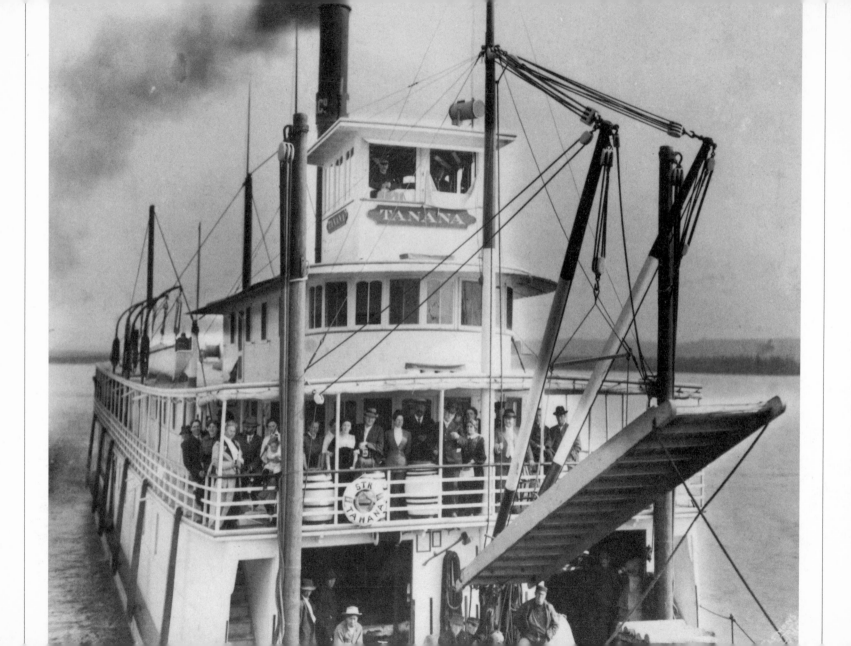

You don't know that it's got hold of you while you're up here, but before you've been "outside" a month, all at once you find it pulling at you—and after it begins it never lets up. It's just Alaska. It calls you and calls you and calls you.

—ELLA HIGGINSON, 1923

Left: The party of J. F. P. Strong on the sternwheeler *Tanana*, photographed between 1910 and 1918. The *Tanana* ran from 1904–21, one of hundreds of steam-powered boats hauling passengers and cargo on Alaska's rivers during their heyday.

A woman identified only as Miss Anderson, teacher at Nome, poses beside what appears to be a food cache in 1913. In 1900, Congress passed legislation requiring municipalities in the territory of Alaska to begin funding schools, but the 1905 Nelson Act established separate schools for natives and whites.

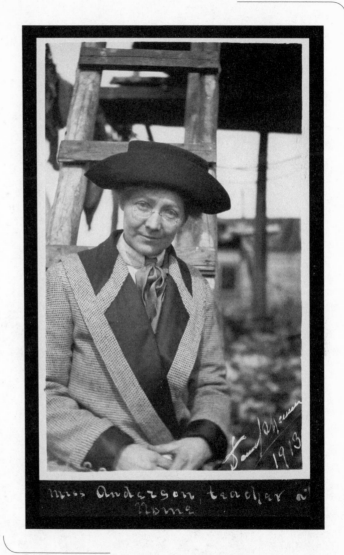

miss Anderson teacher a' Nome

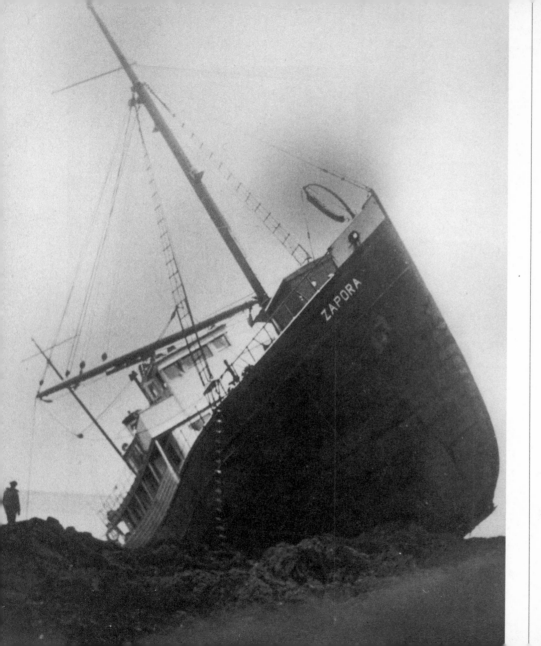

The steamship *Zapora* on a rocky beach. According-ing to a report submitted by the U.S. Secretary of Commerce, the *Zapora* became stranded on Alaska's Nesbitt Reef on December 13, 1911, but floated free later in the day. The vessel sustained an estimated $7,000 in damages.

As the shores of Katmai Bay gradually appeared out of the blue distance when we approached them for the first time (July 11, 1915), they looked weird beyond description. Over the sky was drawn a pall of fine volcanic dust which obscured everything above a thousand feet, cutting off the volcanoes which we wished so much to see, and by its curious, diffused light heightening the unearthly aspect of the landscape, giving it somewhat of that ominous effect that raises one's forebodings at the approach of a storm.

—ROBERT F. GRIGGS, 1922

Jasper Dean Sayre uses a knife and a small torch to sample soil during the 1918 National Geographic expedition to the Katmai ash flat. The top blew from Mount Katmai in 1912, leaving a two-mile crater and creating the Valley of Ten Thousand Smokes. The event, called Novarupta, was the largest volcanic eruption of the twentieth century.

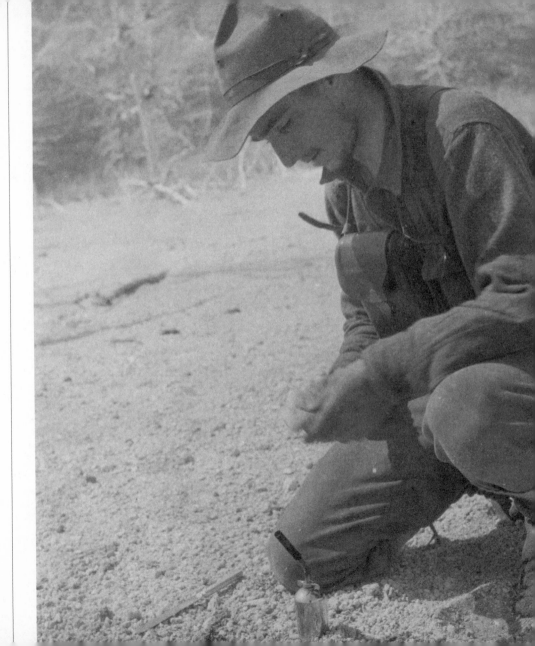

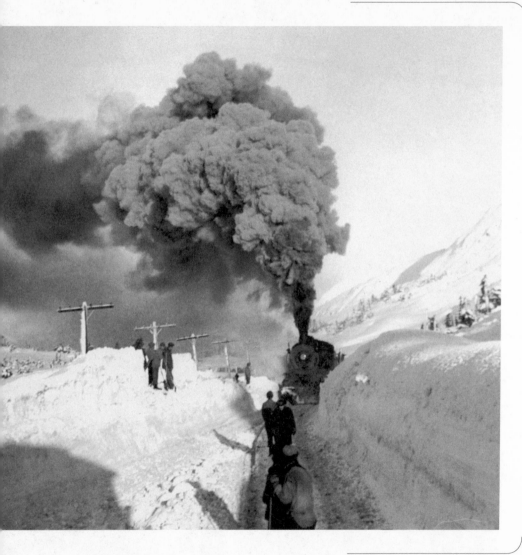

The people of Alaska should be given the full territorial form of government, and Alaska, as a storehouse, should be unlocked. One key to it is a system of railways. These the government should build and administer, and the ports and terminals it should itself control in the interest of all who wish to use them for the service and development of the country and its people.

—PRESIDENT WOODROW WILSON, STATE OF THE UNION ADDRESS, 1913

In this 1920s photograph, men clear snow from a train track, possibly on the Kenai Peninsula. Competition to build railroads began in the late 1800s despite federal penalties and the challenges of climate and rugged terrain. In 1915, construction began on the federally funded Alaska Railroad from Seward to Fairbanks.

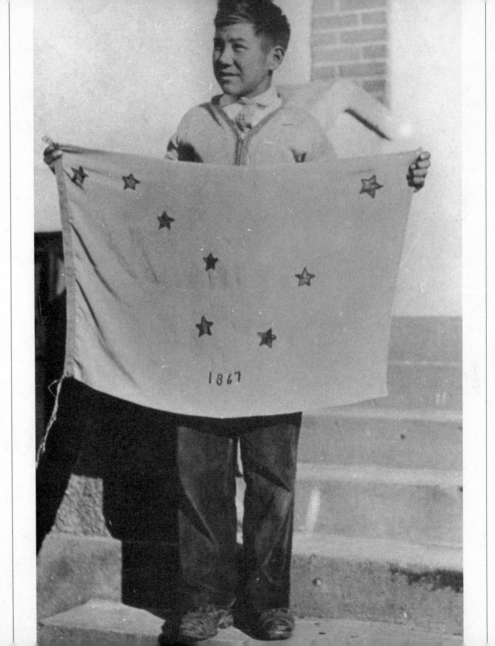

John "Benny" Benson displays his winning design for a flag, chosen in a contest sponsored by the American Legion in 1926. Benson, originally of Chignik, was a thirteen-year-old student at the Jesse Lee Home in Seward. With his entry, he wrote that the blue background symbolized the Alaska sky and the Alaska state flower, the forget-me-not, while the dipper, or Great Bear, represented the strength of the "future state."

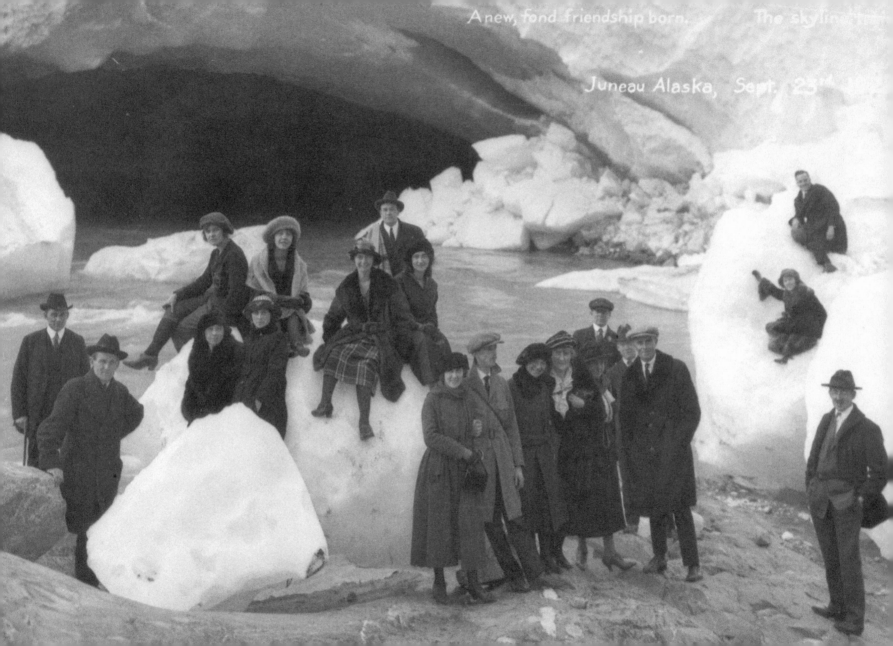

A new, fond friendship born. The skyline that

Juneau Alaska, Sept. 23rd

Thru life's resplendent maze, Our paths lead on and on. They blend, diverge and blend again, They parallel, they cross, They're gone.

—FROM PHOTO INSCRIPTION (LEFT), 1921

Left: Twenty Chautauqua participants at the face of Mendenhall Glacier in Juneau on September 23, 1921. Chautauqua began in New York in 1874 as an experiment in out-of-school learning for adults and quickly spread across the country.

According to the note on this 1923 photograph, this boy with an American flag and the woman beside him are waiting to see Warren G. Harding, the first U.S. president to visit Alaska. Harding traveled to Nenana to drive the golden spike marking completion of the Alaska Railroad connecting Seward and Fairbanks.

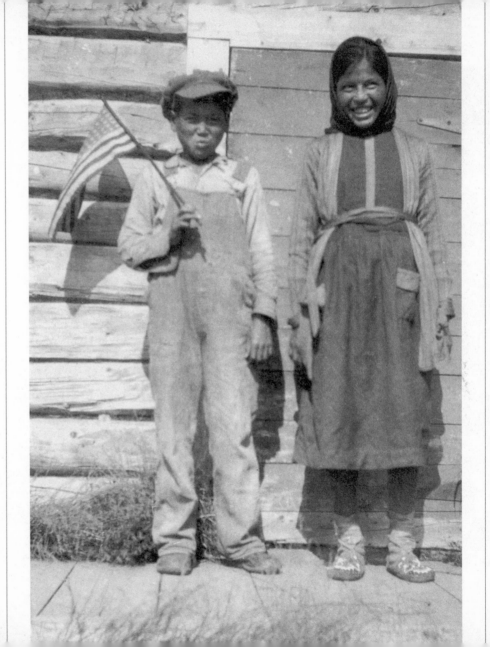

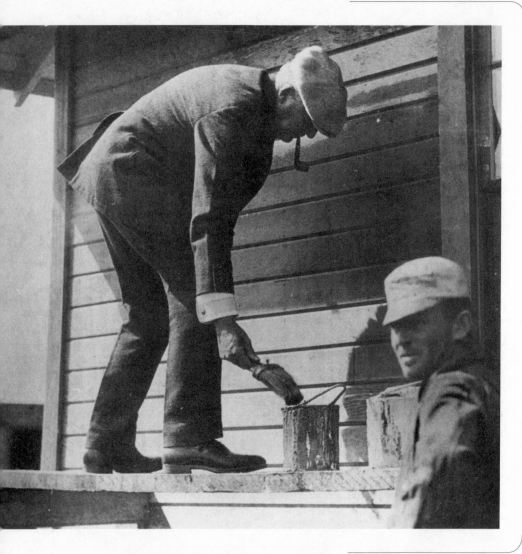

Alaska has enjoyed the distinction of having the White House transplanted to the territory, during which time the plainest citizen was afforded opportunity to come into contact with the highest powers in the land, know them personally and express their views on political and economic questions. Nothing was promised that cannot be fulfilled.

—*ANCHORAGE DAILY TIMES*, JULY 22, 1923

Fred Hamilton watches as President Warren Harding paints a new railroad section house in Willow during his 1923 visit to Alaska. Alaskans applauded Harding's pledge to promote development in the territory and his prediction that Alaska was destined for statehood. Harding died less than two weeks after his visit.

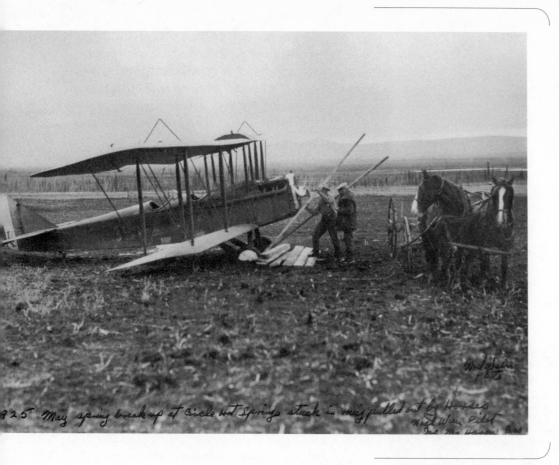

925 May spring break up at Circle Hot Springs stuck in mud pulled out by Horses
Noel Wien Pilot

In May of 1925, two men hoist aviator Noel Wien's biplane out of the mud at Circle Hot Springs. In the 1920s, bush pilots like Wien began flying supplies to remote areas previously accessible only by riverboat or dogsled.

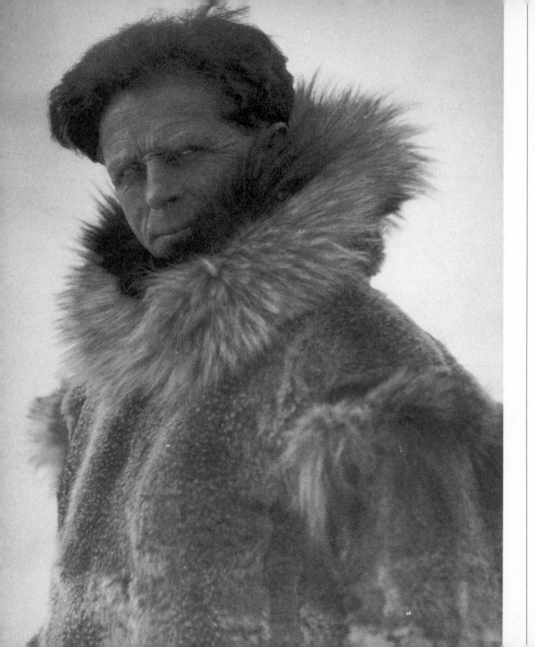

Leonard Seppala is fast taking first place as a driver . . . Seppala, however, is very modest, and dislikes to pose as a hero. When a great ovation is given him, as he leads his winning team off the trail, he simply shrugs his broad shoulders, and says, "Swede's luck," that's all—heaping the honors on the shrine of Luck instead of accepting the praises to which his own resourceful driving and handling of the team entitle him.

—CHARLOTTE CAMERON, 1920

Famous for his role in the 1925 Serum Run to Nome, dog musher Leonard Seppala poses in his fur parka at the end of a race. One of Alaska's premier mushers, Seppala and his lead dog, Togo, crossed a treacherous stretch of trail over Norton Sound to relay diphtheria serum to icebound Nome. Today's Iditarod Trail Sled Dog Race commemorates the event.

Right: A musher, most likely Leonard Seppala (left), runs his dog team along the railroad tracks near Nome. By the 1920s and 1930s, most of the small-gauge railroads linking mining towns had ceased operation, and the tracks were used by many types of vehicles.

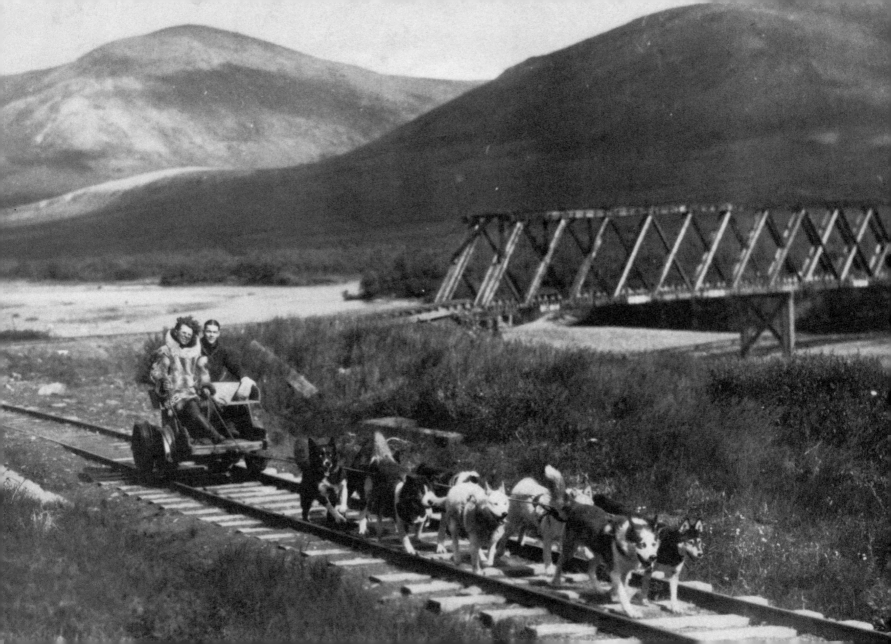

There has been a great deal written about Alaska, and much exaggeration has been indulged in, but on the subject of mosquitoes exaggeration is almost impossible.

—J. D. FRASER, 1923

Eight women wearing mosquito netting stand outside a store along the Richardson Highway. Alaska's infamous mosquitoes inspired all sorts of protective measures, from full body gear to smudging with smoke.

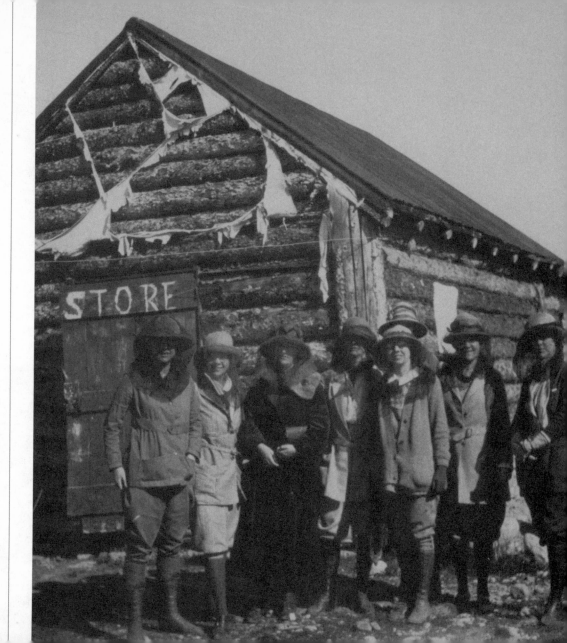

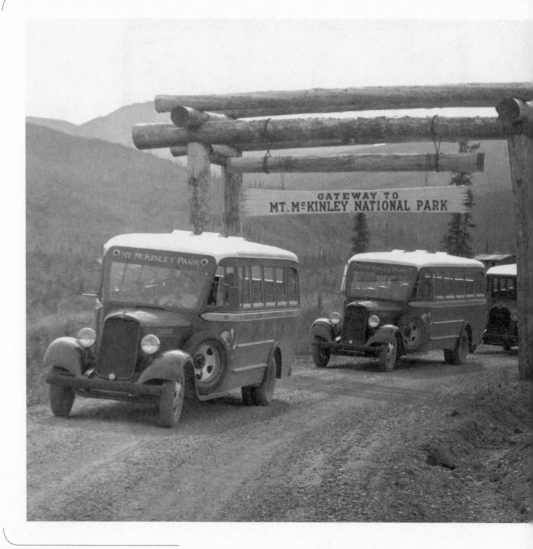

Two park busses and an automobile drive through the gateway to Mount McKinley National Park, now Denali National Park and Preserve, established in 1917. The park road was constructed from 1923 to 1938. Close to four million acres were added to the park in 1980, tripling its size.

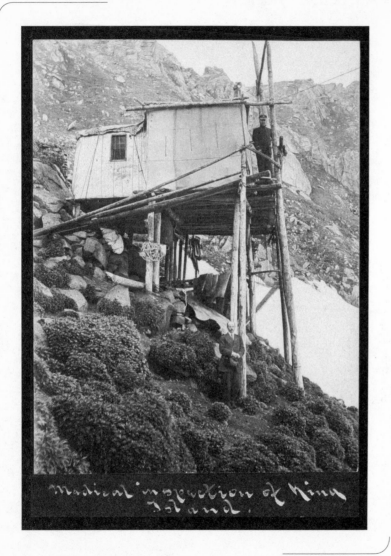

Medical inspection of King Island.

Towards sundown, however, the weather moderated, and enabled us to proceed to our first destination, King's Island, one of the most curious and interesting places it has ever fallen to my lot to visit. King's Island is simply a mass of rock about a mile long and nearly six hundred feet high. On approaching it are noticed what at first appear to be a number of swallows' nests, stuck like limpets to the sheer face of the cliff. These are the summer huts of the King's Islanders—walrus-hide dwellings lashed to the side of the cliff; for the terrible tempests that sweep over this barren rock would make short work of any hut on its summit.

—HARRY DEWINDT, 1899

A medical inspection at King Island (previously called King's Island), eighty-five miles northwest of Nome. A rocky outpost in the Bering Sea, King Island was once home to more than two hundred Inupiaq. Now it is uninhabited.

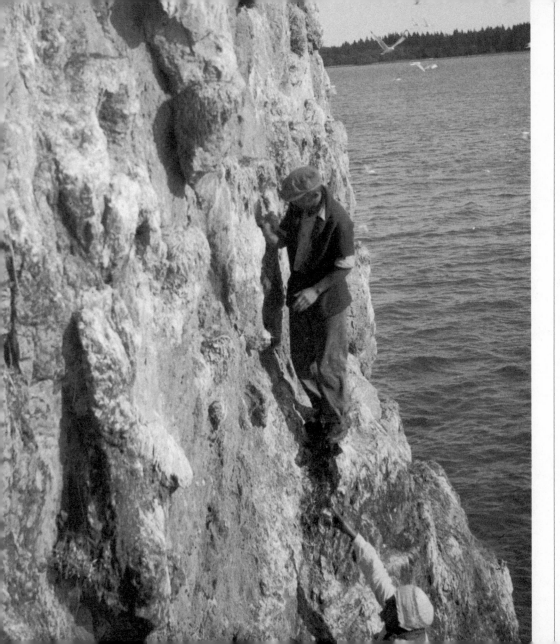

Two men gather kittiwake eggs from cliffs along Boswell Bay in early June of 1933. Egg gathering, a common subsistence activity, grew more selective as certain species became threatened or endangered. Boswell Bay is now a state marine park, adjacent to the Copper River Delta Critical Habitat Area near Cordova.

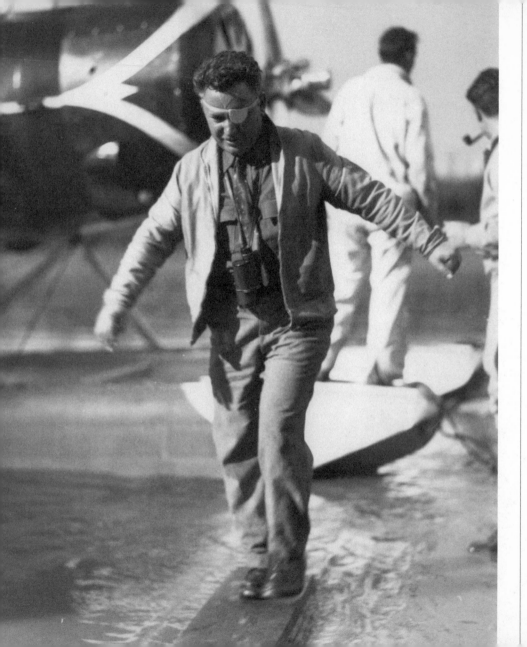

Young and old alike grieved and all who missed seeing the two great figures when they visited here Wednesday regretted the fact, while those who did see and converse with them cherished the experience as a treasured memory.

—*ANCHORAGE DAILY NEWS*, AUGUST 18, 1935

Maneuvering from his floatplane to shore, Wiley Post visits Fairbanks in 1935. Post, the first pilot to fly solo around the world, was touring Alaska with humorist Will Rogers when their plane crashed on takeoff from a river in Point Barrow a few days after this photo, killing both.

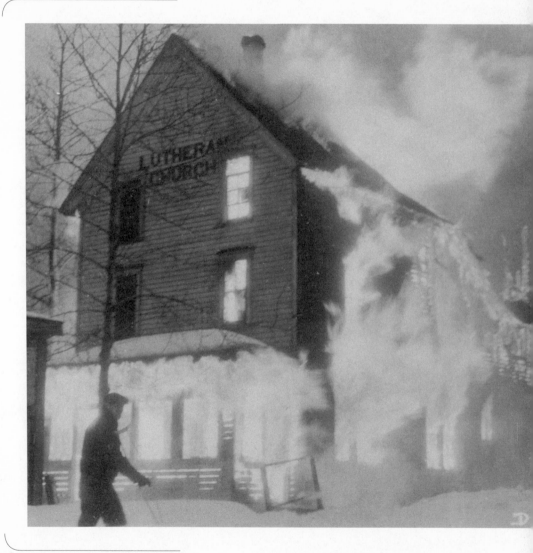

The Lutheran Church on Douglas Island, across the Gastineau Channel from Juneau, burns in 1937. This blaze was the last of three great fires that destroyed most of the historic buildings on the island. With scant firefighting resources in many communities and ample wilderness to burn, Alaskans struggled with fires since the early days of the territory.

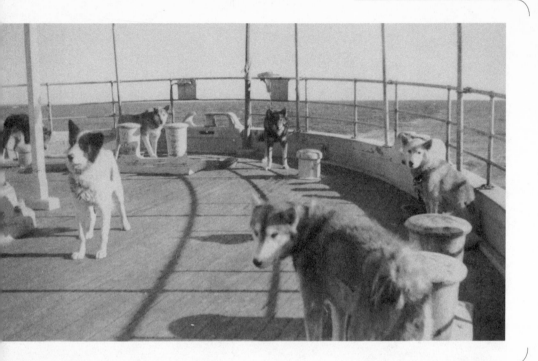

In the gray of the Arctic twilight, as close by my side she lies, I ponder the fathomless mystery that broods in my wolf dog's eyes . . . Together we've crossed the frozen wastes, we have breasted the howling gale. We have seen the glory of Northern Lights; together we've starved on the Trail. Is there something that holds her to me, some secret I cannot know? An expiation of crime or wrong that happened long ages ago?

—ESTHER BIRDSALL DARLING, 1912

Six of nineteen sled dogs tied up on a ship's deck, in transit from Bethel to Antarctica in 1939. As in Alaska, sled dogs were vital to transportation in Antarctica, where Roald Amundsen beat Robert F. Scott to the Pole in no small part because of his expertise with dog teams.

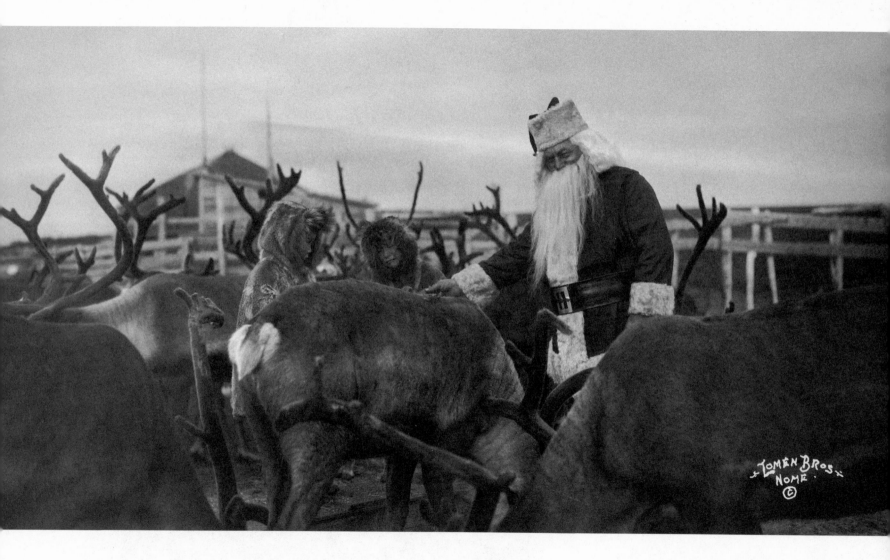

Previous: Santa visits reindeer in Nome in this photo taken sometime between 1908 and 1934. When missionary and General Agent of Education Dr. Sheldon Jackson brought the first reindeer to Alaska in 1891, his vision had more to do with providing a livelihood for Alaskan natives than assisting Santa with his annual trek.

This undated photo of a bear standing on a man's back, apparently clapping, is one of several archival examples of how early Alaskans unwittingly treated wild animals as pets. Today the dangers of acclimating wildlife to humans are widely understood, and bears are given the wide berth they deserve.

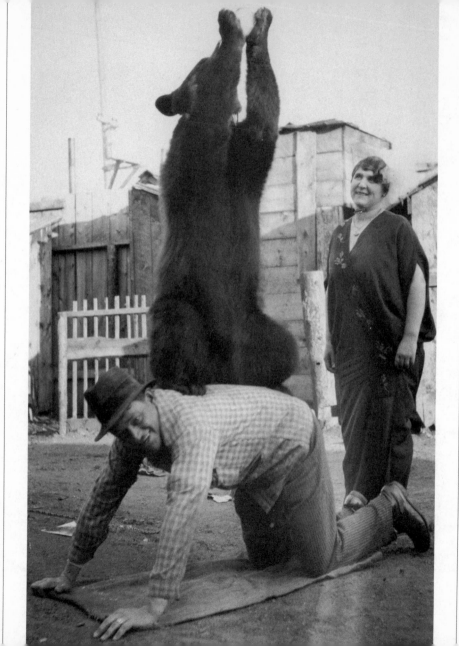

Alaska is calling me back again; she's tugged at my heart all day. These comforts and pleasures, you're welcome to, but I must up and away— Away to the land of a thousand charms, which a city-slave cannot see, where the mind is calmed, and the soul expands, and the heart grows strong and free.

—ISABEL AMBLER GILMAN, 1914

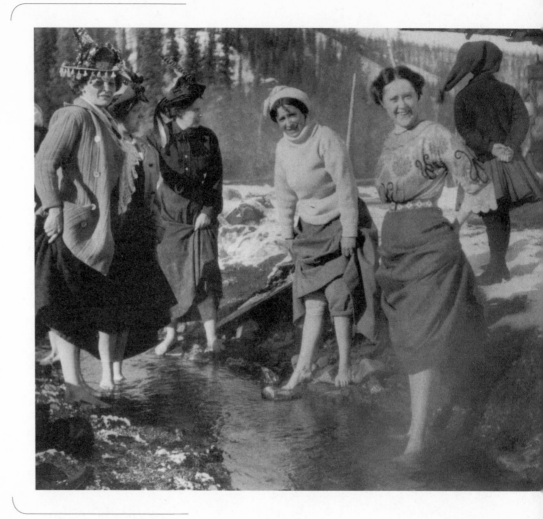

In this undated photo, women soak their feet in a warm stream, possibly at Chena Hot Springs, sixty miles east of Fairbanks. Eager to ease the pains of rheumatism, miner Robert Swan searched for a month in the summer of 1905 to locate steaming waters reported by a U.S. Geological Survey team. Early analysis revealed sulfate, chloride, and bicarbonate of soda—components unlike those in any other American hot springs. Today Chena Hot Springs is the site of Alaska's first geothermal power plant.

Who built its towns, its roads and trails,
Who planned its railroads, and laid the rails,
Who guide in council, in creating homes,
And in laying a State's foundation stones.

—JAMES WICKERSHAM, 1938

COMING OF AGE: 1938–1977

Though no great poet, James Wickersham understood the pioneering spirit of Alaska. Yet not even this elder statesman could have foreseen the changes that swept the country from the mid- to late twentieth century.

World War II thrust Alaska to center stage. In the summer of 1942, Japan occupied the remote Aleutian Islands of Attu and Kiska. The army and navy scrambled to build new bases and rushed thousands of troops north to fill them.

In less than eight months, crews constructed the crude 1,420-mile Alaska–Canada Military Highway (Alcan) and military convoys began crawling north with supplies. Air traffic soared to new heights under the Lend-Lease program, with pilots delivering nearly 8,000 aircraft to the Soviet Union via Alaska.

Construction boomed after the war as tensions escalated between the United States and its former Soviet ally, prompting expansion of military bases in Fairbanks and Anchorage. As Alaska's population surged to 138,000 in 1950, the push for statehood accelerated. Following a series of struggles and setbacks, Alaska finally became the nation's forty-ninth state on January 3, 1959.

With statehood came new challenges. The state's leaders grappled with native rights, land claims, and conservation issues. The 1964 Good Friday Earthquake devastated Anchorage, Valdez, Seward, and other coastal communities. Federal spending declined in the 1960s, though burgeoning timber and fishery industries compensated for some of the loss.

Then came the greatest boom since the Klondike—the 1968 discovery of massive oil fields on Alaska's North Slope. Following a frenzy of construction, the Trans-Alaska Pipeline began carrying oil from Prudhoe Bay to Valdez in the summer of 1977.

Only 110 years after Secretary of State William Seward was chided for purchasing a chunk of frozen ground, Alaska had come into its own.

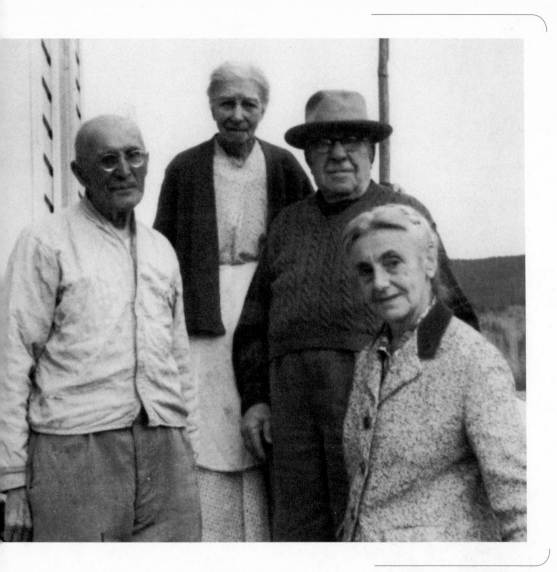

Four Alaskan pioneers photographed in Big Delta. From left to right: John Hajdukovich, a Montenegrin immigrant who built a roadhouse along the Fairbanks–Valdez Trail in 1909; Rika Wallen, a Swedish immigrant who ran and later purchased the roadhouse from Hajdukovich in 1923; Robert Bloom, who arrived in Alaska during the Klondike gold rush of 1898; and Jessie Bloom, who came to Alaska in 1912.

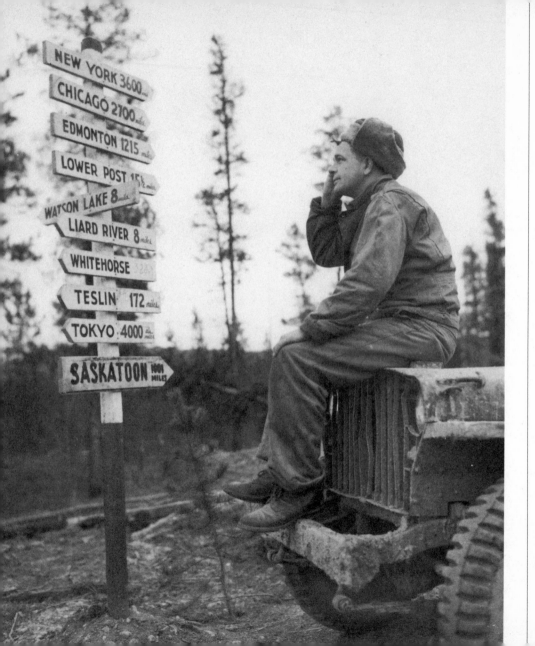

A worker ponders a signpost along the Alaska Highway, apparently not far from Watson Lake, Yukon Territory. Carl K. Lindsay, an army soldier working on the construction of the Alaska Highway in 1942, started what became a "signpost forest" near Watson Lake. Travelers continue to add signs to the collection, which now tops 55,000. More than 10,000 U.S. soldiers built the 1,420-mile Alcan Highway in eight months.

Some of the photos were made
under fire, and we too had our
casualties . . . This picture clearly
reveals the rough terrain over
which we went after the Japanese.
Their snipers kept just above the
fog lines and hid in crevices.

—U.S. NAVY OFFICIAL PHOTO FROM ACME
PHOTO, VERSO 5/26/43

Soldiers from an advanced command post carry
a wounded comrade in the battle for Attu, west-
ernmost island of the Aleutian Chain. On June 7,
1942, Rear Admiral Sentaro Omori landed 1,200
Japanese troops on Attu. Eleven months later,
American forces began a successful three-week
battle to retake the island, an effort second only
to Iwo Jima in terms of proportionate casualties
in the Pacific theater.

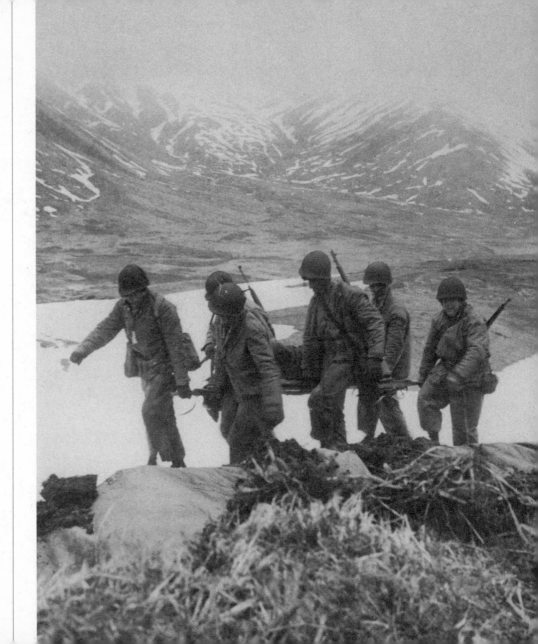

A pilot and a sailor on the Aleutian tundra with two Unangan boys. Unangan (Aleut) hardships began with disease and enslavement brought by the Russians in the eighteenth century and continued through World War II, when forty-two Aleut were taken prisoner by the Japanese and 881 were relocated from nine villages for the remainder of the war.

In 1942, my wife and our four children were whipped away from our home . . . all our possessions were left . . . for mother nature to destroy . . . I tried to pretend it really was a dream and this could not happen to me and my dear family.

—BILL TCHERIPANOFF SR., AKUTAN ALEUT EVACUEE, NATIONAL PARK SERVICE ARCHIVES

In this 1942 photograph, a Russian Orthodox priest stands in a doorway at one of five refugee camps in Southeast Alaska. Suffering from disease and substandard living conditions, the relocated Aleut clung to their faith, constructing a makeshift church in one of the camps. When the displaced residents were finally returned to their homes in the Aleutian Islands, they found them pummeled by weather and ransacked by American soldiers. Restitution was finally granted by Congress in 1988.

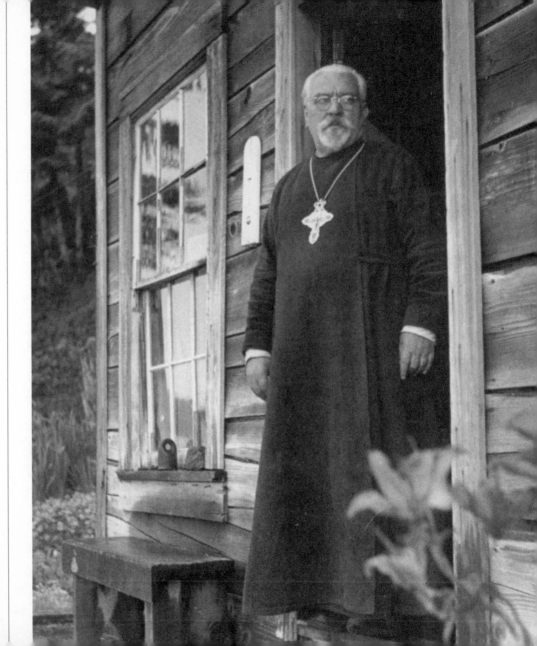

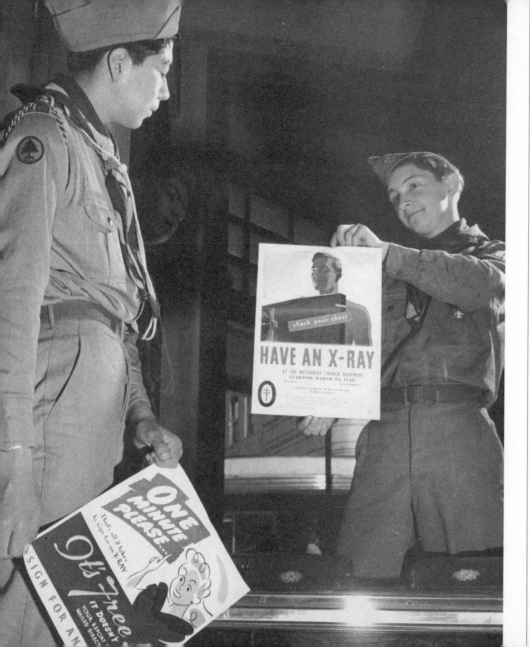

These various schools at such unheard places are extremely interesting.

—ALICE PALMER HENDERSON, 1898

"It's free. It's painless." Boy Scouts promote tuberculosis screening in Sitka. Two years prior to this 1948 photo, tuberculosis caused 46 percent of deaths among Alaskan adults. Tremendous progress has been made in controlling the disease, but a high latent rate remains among Alaskan residents, especially in rural areas.

Right: School portrait from the 1948–49 year in Galena. The classroom is a Quonset hut—a portable, arched, ribbed structure brought to Alaska by the U.S. military during World War II. The river village of Galena was established in 1918 near an Athabascan fish camp. A school was built in the 1920s, followed by a military airfield during the war.

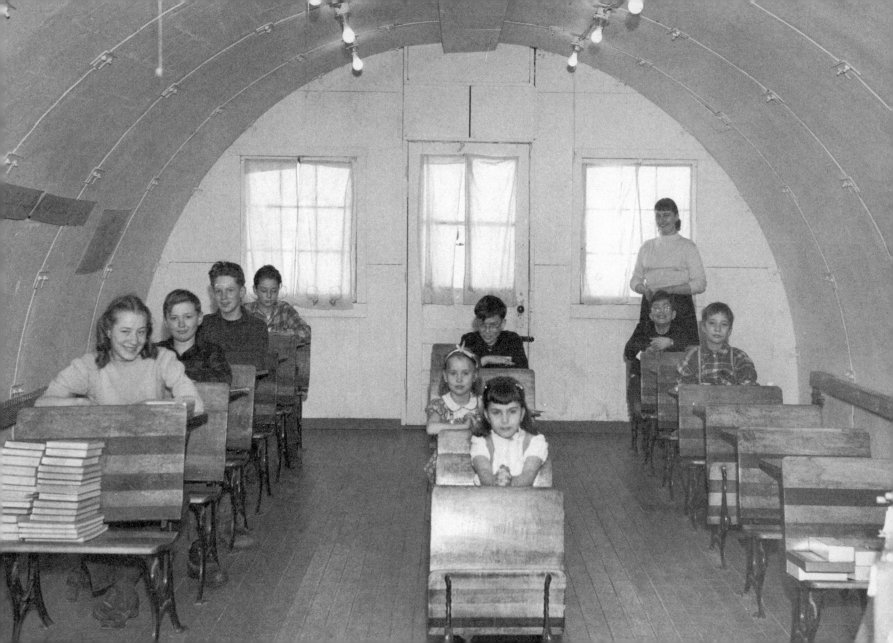

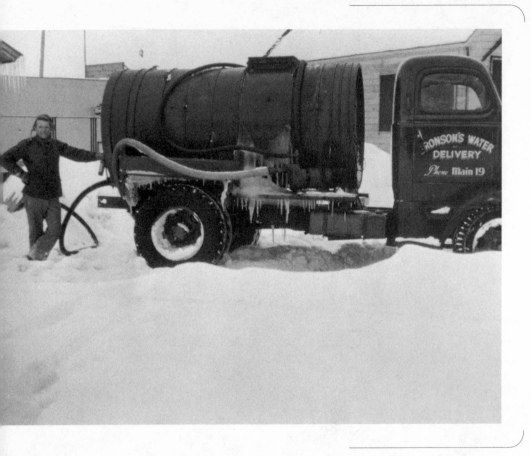

In the winter of 1948, a delivery driver pumps water into a tank in Nome. Residential wells and traditional city water service are mostly unavailable in communities underlain by permafrost, forcing residents to either have their water delivered or haul it themselves.

As throughout the project, moving the mission house, the last building to make the trip, could begin only after the ground had frozen hard.

—FROM ORIGINAL PHOTO CAPTION

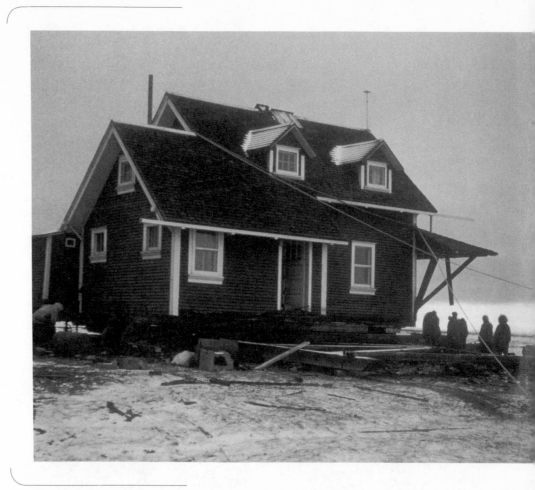

The mission house in Point Hope is raised in preparation for moving across frozen ground. Because of permafrost and other unstable soils, Alaskan buildings must sometimes be relocated to better ground or improved foundations.

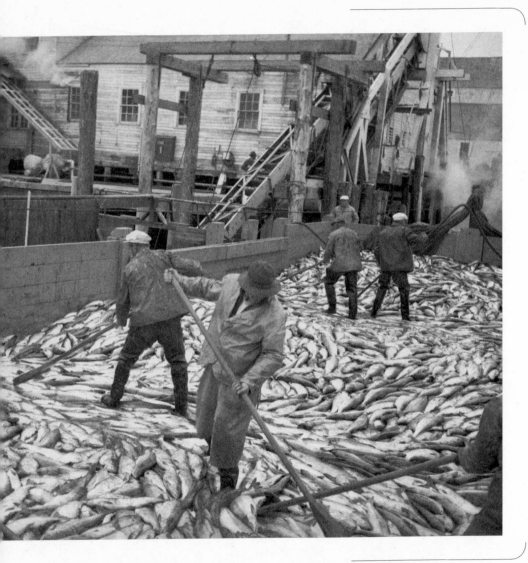

Unloading salmon from a fishing boat at a cannery in Bristol Bay in the 1950s. In order to restore salmon fisheries decimated by overfishing, Secretary of Commerce Herbert Hoover promoted passage of the 1925 White Act, ensuring that at least half of Alaska's salmon remain free from capture so they could spawn.

The whole nation will profit by an Alaska that is populous, prosperous, strong, self-reliant—a great northern and western citadel of the American idea. Statehood would automatically bring us far along that high road.

—ERNEST GRUENING, 1955

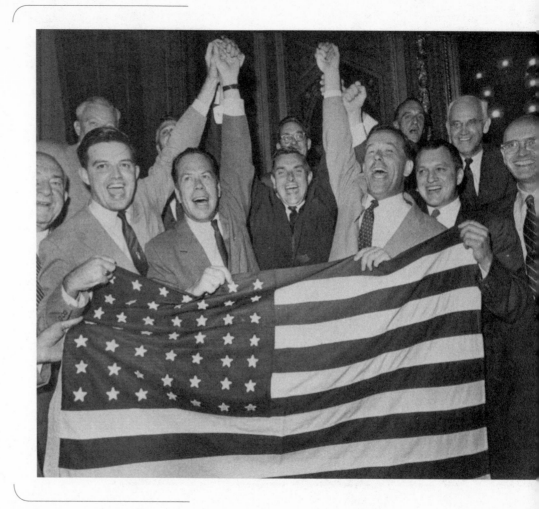

The long struggle for Alaska statehood came to an end on June 30, 1958, with a 64–20 U.S. Senate vote. Celebrating, from left to right: former Alaska governor Ernest Gruening, Idaho senator Frank Church, California senator Thomas Kuchel, Washington senator Henry Jackson, Alaska GOP chairman (and future governor) Wally Hickel, Utah senator Arthur Watkins, and Oregon senator Richard Neuberger.

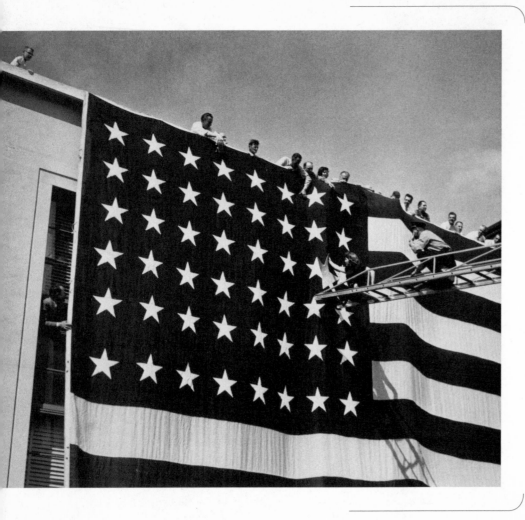

Oh not for us the easy ways, our task is long and tough, the country here is strange to us and most of it is rough. But we have the will to conquer and we'll make Alaska great, If Uncle Sam will say the word that will make our land a State. Oh we know that we'll be proud that day and Uncle Sam will brag, When Alaska's star is set among the stars that deck the Flag!

—D. A. NOONAN, 1921

On June 30, 1958, Fur Rendezvous Queen Rita Martin commemorates passage of the Alaska Statehood Act by pinning a forty-ninth star on the U.S. flag draped over the Federal Building in Anchorage. President Eisenhower signed the act on July 7, 1958, and Alaska was officially admitted into the Union on January 3, 1959.

Right: In this 1959 photo, reindeer ride inside a Wien Alaska airplane departing from Anchorage, with flight crew and reindeer herders in the background.

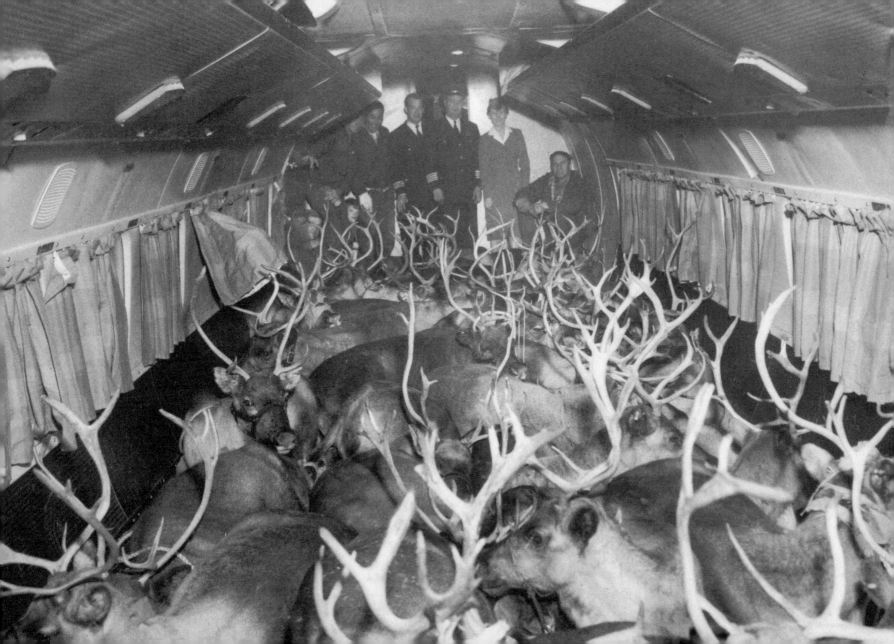

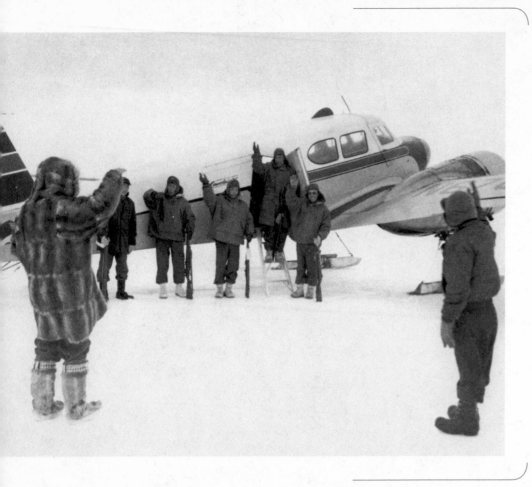

The 49th State of Alaska is most air-minded. Everybody and everything travels by air.

—ALASKA VISITORS ASSOCIATION

National Guard troops wave in front of a plane on skis in Bethel, a staging area for personnel from village armories. The Alaska Army National Guard, formed in 1940, saw no significant deployments until 2004, when battalions were sent to Iraq.

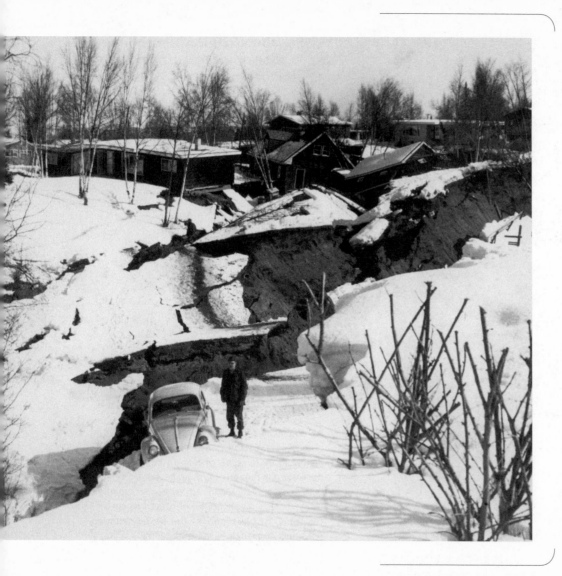

Heaved ground and homes in the Turnagain area of Anchorage following the Good Friday Earthquake on March 27, 1964. Measuring 9.2 on the Richter scale, the quake damaged thirty blocks of downtown buildings, leveled seventy-five Anchorage homes, and caused 131 deaths throughout Alaska and along the Pacific coast—most from tsunamis.

Log cabins stuffed with moss should be wonderful in the tropics. I'm about frozen.

—ROCKWELL KENT, 1920

An abandoned cabin in Hope, photographed in June of 1972. Established as a gold mining community in 1896, some of Hope's buildings were destroyed in the 1964 earthquake, but many—not built to last—fell victim to time and weather. Nevertheless, thanks to the efforts of its current residents, Hope is one of the best-preserved gold rush communities in Southcentral Alaska.

On July 3, 1974, engineers involved in the construction of the Trans-Alaska Pipeline study "pigs" at Prudhoe Bay. Construction of the 800-mile pipeline from Prudhoe to Valdez involved multiple engineering challenges, including bracing for permafrost, earthquake proofing, and the use of mechanical "pigs" to clean and gather information about the condition of the line.

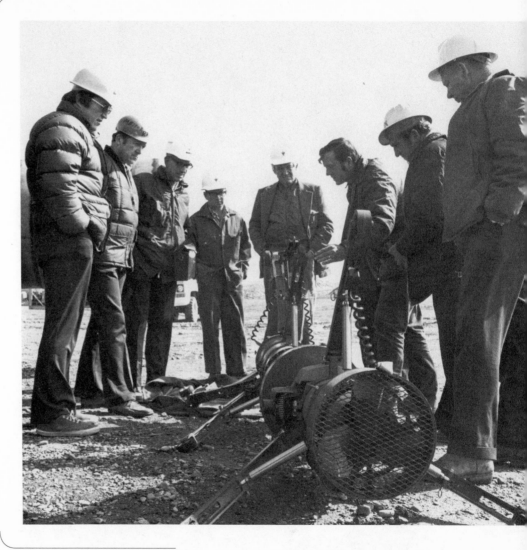

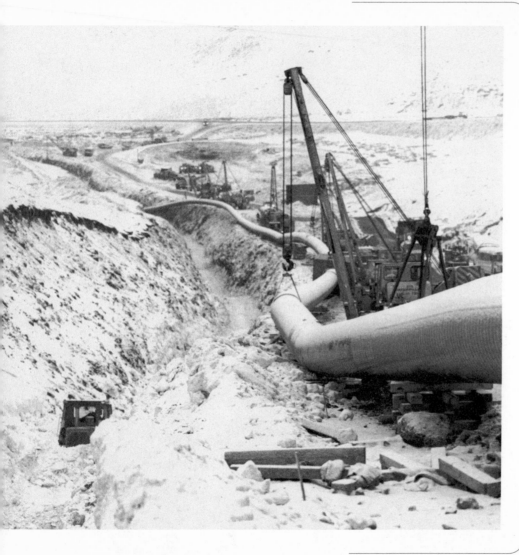

The early development and delivery of oil and gas from Alaska's North Slope to domestic markets is in the national interest because of growing domestic shortages and increasing dependence upon insecure foreign sources.

—CONGRESSIONAL FINDINGS AND DECLARATION, TITLE 43, CHAPTER 34, THE TRANS-ALASKA PIPELINE, NOVEMBER 16, 1973

A view of the Trans-Alaska Pipeline construction north of Atigun Pass. The pipeline crosses three mountain ranges and thirty-four rivers and streams, with a little less than half its length running underground. Flowing at five to seven miles per hour, oil travels from the North Slope to Valdez in about five and a half days.

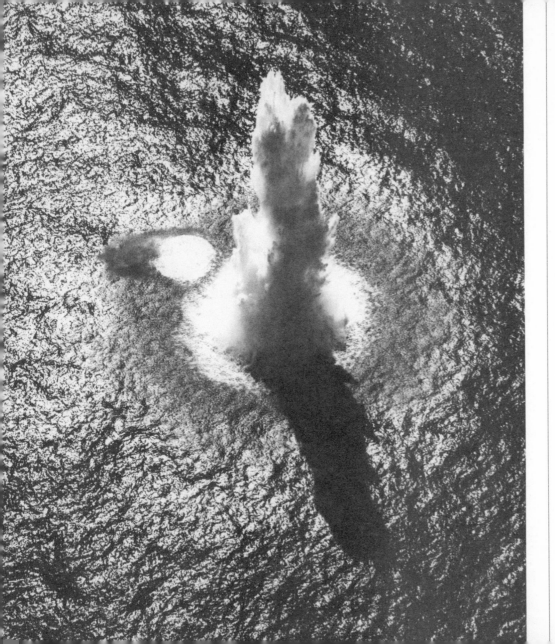

An aerial view of a detonation in the Pacific Ocean during World War II. In the decisive Battle of the Komandorski Islands, Rear Admiral Charles McMorris deterred Japanese supply ships by shooting high explosives that mimicked bombs. Hungry and war-worn, Japanese troops on Attu were virtually annihilated by the end of May 1943. In 2008, Japanese soldiers returned to Attu to gather the remains of approximately 2,000 dead.

Never before this had I been embosomed in scenery so hopelessly
beyond description.

—JOHN MUIR, 1915

ALWAYS AND FOREVER
THE GREAT LAND

In the beginning was the land. Soaring mountains. Rushing rivers. Sprawling forests. Alaska's expansive beauty engages the imagination and nourishes the soul.

Glaciers carve out landscapes by the inch. Earthquakes and volcanoes transform them overnight. Winds sweep the potholed tundra, rippling ponds and grasses. Low-lying lichen, moss, and berries cling to frozen soils. Ancient spruce and cedar tower over coastal rainforests teeming with life.

A land this big defies description, but one thing is for certain: this is not an easy place. From microscopic algae spreading over summer snowfields to giant whales plunging through arctic waters, survival is the first order of business and adaptation the key.

Remnants of a time when the north was balmy, Alaska's rich deposits of oil, gas, and minerals stir up controversy and cash. Fish and timber add to Alaska's resource bonanza.

Native allotments aside, less than 1 percent of Alaska's land is privately owned. The rest belongs to the ages—to the lynx and caribou, the walrus and seal, the marmot and eagle—that know nothing of debates that rage over issues like development and global warming.

Challenged, exploited, contested, sequestered—in the end, it is the land that will remain.

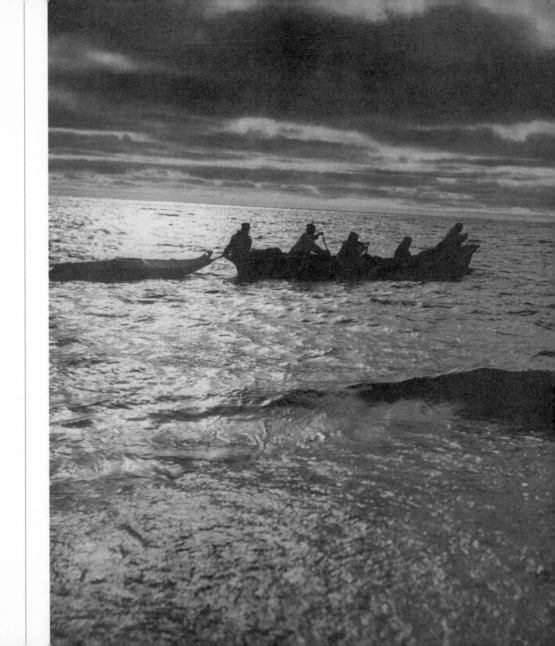

Paddling a *bidarka*, or skin boat, across a stretch of open water in a photo titled "Land of the Midnight Sun." Originally with one or two holes, these kayaks were redesigned to hold more passengers upon the request of Russian traders.

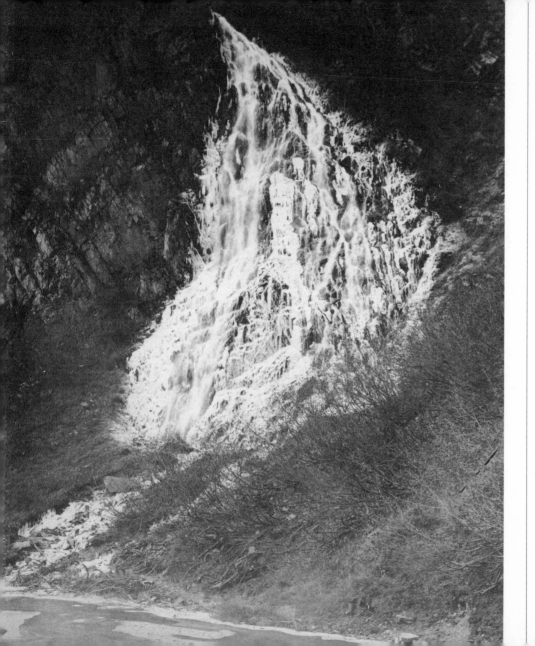

We find ourselves vainly endeavoring to comprehend the immensity of these grand and sublime surroundings, trying to realize that the vast waterfalls pouring over the bluffs with continuous roar are fed by melting snows and glaciers far above and miles away . . . They roar you to sleep, rumble in your ears until you awake to feast your eyes on their spreading spray and, speechless with admiration, you stand and gaze at the beautiful and variegated colors of their rainbows.

—ADDISON M. POWELL, FROM THE ABERCROMBIE EXPEDITION, 1900

Windy Falls in Keystone Canyon, along the original Fairbanks to Valdez Trail. In 1899, Captain W. R. Abercrombie rerouted the treacherous Valdez Glacier Trail through Keystone Canyon and Thompson Pass, where the Richardson Highway runs today.

To the lover of pure wildness Alaska is one of the most wonderful countries in the world.

—JOHN MUIR, 1915

Few clues accompany this photo acquired from the Alaska–Juneau Gold Mining Company, incorporated in 1897. The caption identifies this only as a "constructed wooden object with water coming out of it on a downhill grade." The mining company engineered several dams to power mining operations on its claims.

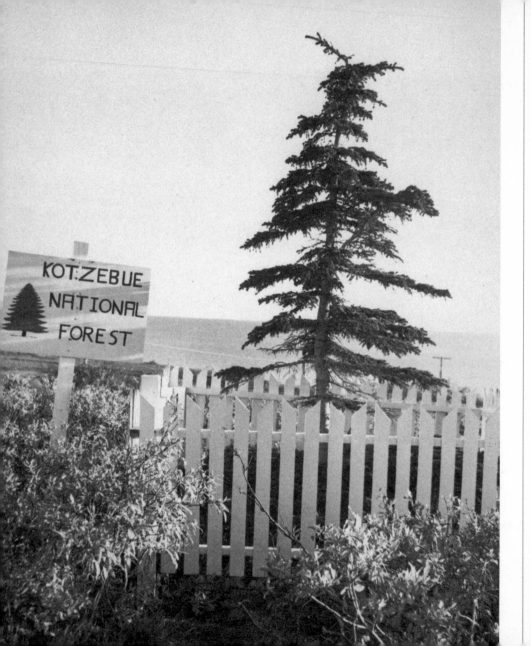

A lone spruce tree inhabits the locally proclaimed "Kotzebue National Forest." Located thirty-three miles north of the Arctic Circle on Alaska's western coast, Kotzebue is built on tundra underlain with permafrost that prohibits growth of most trees. Permafrost lies beneath approximately 80 percent of Alaska.

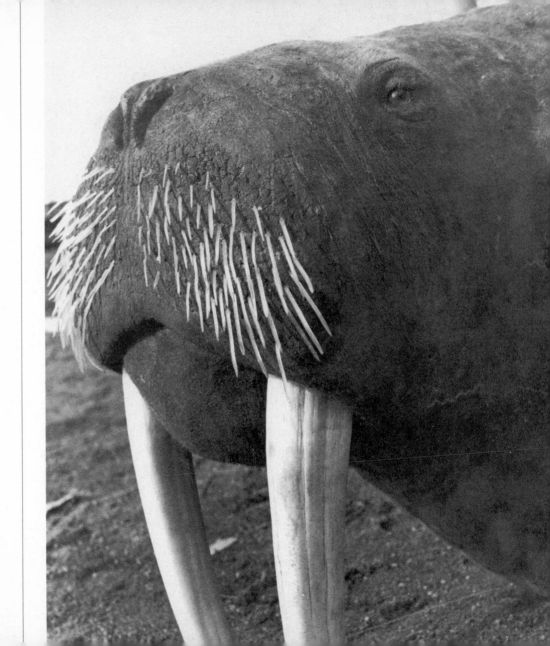

Close-up of a walrus, showing whiskers and tusks, taken in the 1960s. The largest pinnipeds in the Arctic, walrus approach two tons in weight. Those with the largest tusks tend to dominate the herd.

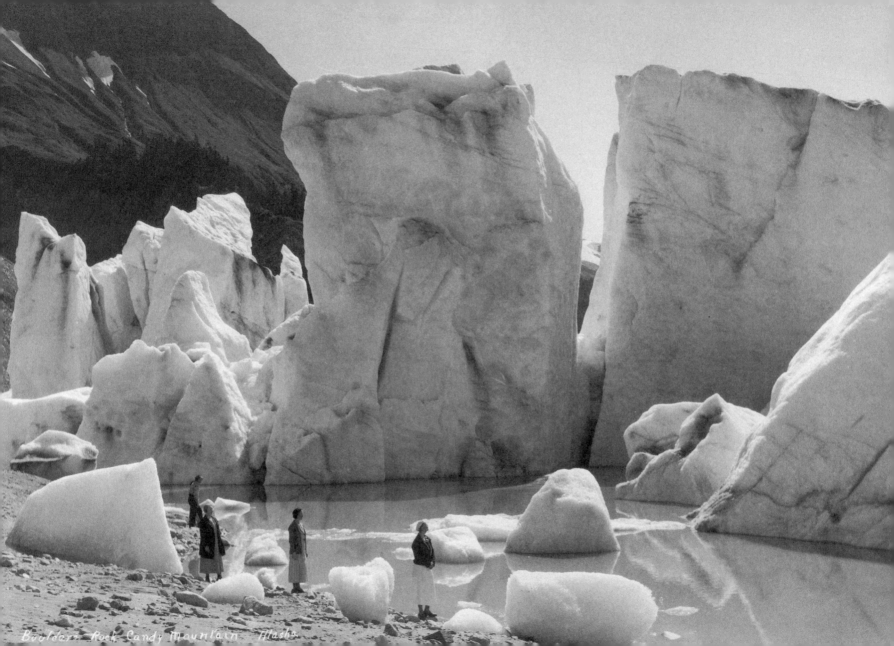

Boulders Rock Candy Mountain - Alaska

Imagine, if you can, a rolling sea of ice which stretches away to meet the horizon on all sides . . . The surface of the glacier is always windswept, so that here and there where the ice is bare, the dazzling whiteness of the snow is augmented by the blinding brilliancy of the reflected light from these ice mirrors.

—ARTHUR ARNOLD DIETZ, 1914

Left: This Heath A. Ives photo from the early 1900s is captioned "Boulders Rock Candy Mountain Alaska." The ice appears to have calved from a glacier.

"Traveling on skis at the rate of 30 miles an hour" reads the verso on this photo by F. H. Nowell. Frozen lakes, rivers, and tundra offer all sorts of opportunities for transportation and recreation. Dressed in a fur parka and toting a skin sail, this unidentified adventurer demonstrates an early form of wind skiing, now done with traction kites.

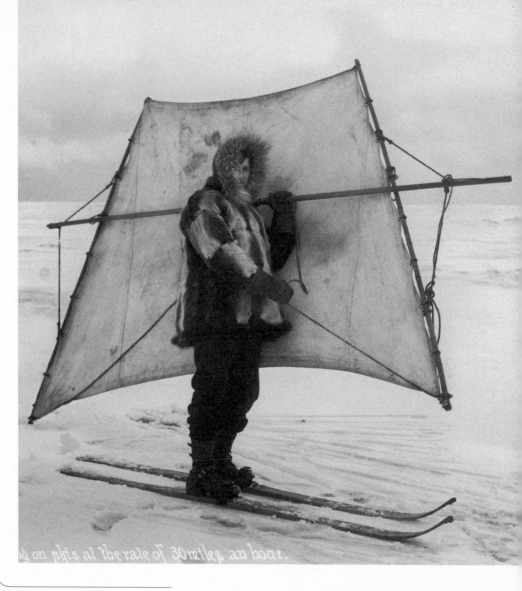

ng on skis at the rate of 30 miles an hour.

Have you gazed on naked gran-
deur where there's nothing else
to gaze on, set pieces and drop-
curtain scenes galore? Big moun-
tains heaved to heaven, which
the blinding sunsets blazon, black
canyons where the rapids rip and
roar? Have you swept the visioned
valley with the green stream
streaking through it? Searched
the Vastness for a something you
have lost?

—ROBERT SERVICE, *THE SPELL OF
THE YUKON*, 1907

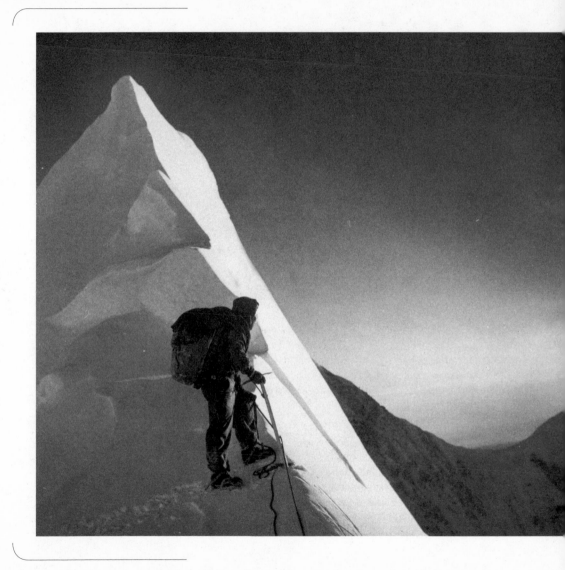

A climber near the summit of Mount Kennedy,
Yukon Territory, in March of 1965. The 14,000-
foot peak of the Wrangell–St. Elias Range lies in
Kluane National Park, bordering Alaska. It was
named for President John F. Kennedy after his
assassination and was first climbed by a National
Geographic Society expedition that included his
brother, Robert, in 1965.

Photographed by Bradford Washburn from 2,200 feet on September 18, 1938, a gold dredge on Ester Creek near Fairbanks, with piles of tailings left in its wake. Dredges floated in ponds they created as they dug for gold and spit back tons of gravel. Dredges vitalized the Alaskan economy after the easy gold was gone, but each dredge chewing through 10,000 cubic yards a day left its mark on the landscape.

Alaska! The word alone thrills us with the glamour of exploration and adventure. Thousands of miles of unexplored rivers, vast expanses of virgin forest, glaciers, gold mines, pack trains—all these flash through our minds at the very mention of that magic country.

—BRADFORD WASHBURN, 1930

Pilot Don Sheldon stands beside his plane, dwarfed by approximately one vertical mile of sheer granite on the east face of Mount Dickey, one of the tallest rock walls in the world. Famed climber and photographer Bradford Washburn captured this image just seven days before he and David Fischer made the first-ever ascent of the mountain on April 19, 1955.

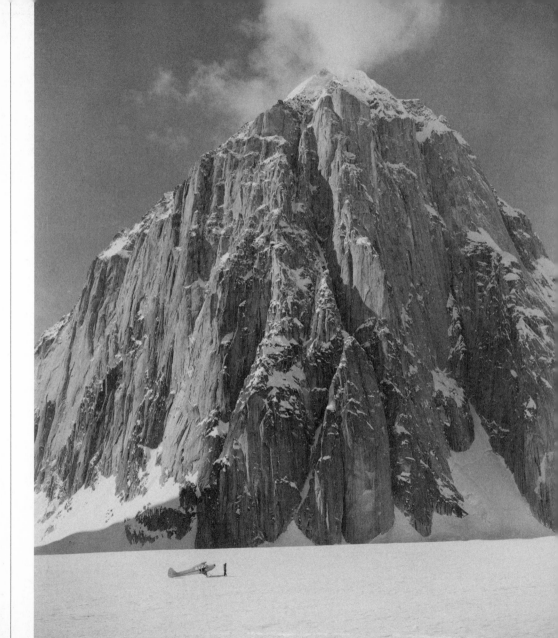

Let us probe the silent places, let us seek what luck betide us; Let us journey to a lonely land I know. There's a whisper on the night-wind, there's a star agleam to guide us. And the Wild is calling, calling . . . let us go.

<div align="right">

—ROBERT SERVICE, *THE CALL OF THE WILD*, 1907

</div>

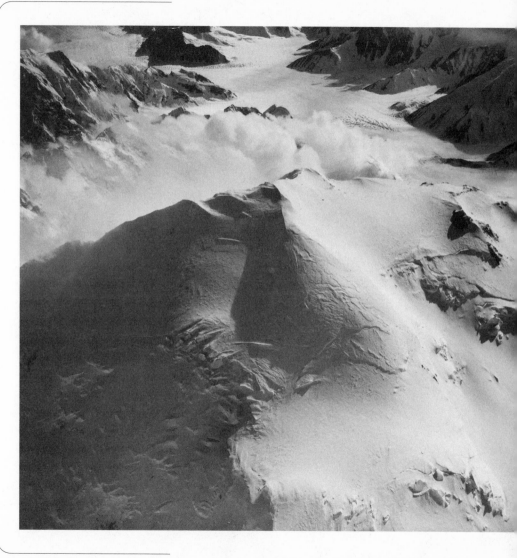

Mount McKinley's south peak, seen from the southwest over Carter Horn, photographed by Bradford Washburn on July 16, 1977. Taking thousands of photos, Washburn pioneered the use of aerial photography for mountaineering. Washburn (1910–2007) was also an intrepid climber, cartographer, and aviator.

SOURCES

Abercrombie, Captain W. R. *Alaska, 1899*. Washington, D.C.: Government Printing Office, 1900.

Alaska's Digital Archives. *Everything Flies in Alaska* (Kay J. Kennedy Aviation Photograph Collection). Available from vilda.alaska.edu.

Aleutian World War II National Historic Area. *Aleut Internment*. Available from www.nps.gov/archive/aleu/AleutInternmentAndRestitution.htm [cited 5 June 2008].

Brown, William E. *Cultural Resources Management in Alaska*. Available from crm.cr.nps.gov/archive/02-3/2-3-all.pdf.

Burroughs, John. *Far and Near*. Boston: Houghton-Mifflin, 1904.

Cameron, Charlotte. *A Cheechako in Alaska and Yukon*. London: T. Fisher Unwin Ltd., 1920.

Crad, Joseph. *White Hell of the North*. London: Sampson Low, 1900.

Curtin, Walter R. *Yukon Voyage*. Caldwell, ID: Caxton Printers, 1938.

Darling, Esther Birdsall. *Up in Alaska*. Sacramento: Joseph M. Anderson, 1912.

Davis, Mary Lee. *We Are Alaskans*. Boston: W. A. Wilde, 1931.

DeWindt, Harry. *Goldfields of Alaska to Bering Straits*. London: Chatto & Windus, 1899.

Dietz, Arthur Arnold. *Mad Rush for Gold in the Frozen North*. Los Angeles: Time's Mirror, 1914.

Dole, N. H. *Our Northern Domain*. Boston: Dana Estes & Company, 1910.

Fraser, J. D. *The Gold Fever*. Fraser, 1923.

Gilman, Isabel Ambler. *Alaskaland*. New York: The Alice Harriman Company, 1914.

Gordon, George Byron. *In the Alaskan Wilderness*. Philadelphia: John C. Winston, 1917.

Griggs, Robert F. *The Valley of Ten Thousand Smokes*. Washington, D.C.: National Geographic Society, 1922.

Grim, Charles W. "Preserving the Treasure" (keynote address, 2004). Available from www.ihs.gov/PublicInfo/PublicAffairs/Director/2004_Statements/Heritage_Month_2004-Nov_1.pdf [cited 27 May 2008].

Gruening, Ernest, "American Colonialism" (keynote address to constitutional conventions, November 9, 1955).

Harris, A. C. *Alaska and the Klondike Gold Fields*. J. R. Jones, 1897.

Henderson, Alice Palmer. *The Rainbow's End: Alaska*. Chicago: Herbert S. Stone, 1898.

Higginson, Ella. *Alaska: The Great Country*. New York: Macmillan, 1923.

James, Sarah. *We Are the Ones Who Have Everything to Lose*. Available from www.gwichinsteeringcommittee.org/whoweare.html [cited 10 June 2008].

Kent, Rockwell. *Wilderness*. New York: Halcyon House, 1920.

Morgan, Lael. *The Last of the Independents?* Available from www.aliciapatterson.org/APF001972/Morgan/Morgan04/Morgan04.html [cited 28 May 2008].

Muir, John. *Travels in Alaska*. Boston: Houghton-Mifflin, 1915.

National Endowment for the Arts, *NEA National Heritage Fellowships: Nathan Jackson* (1995). Available from www.nea.gov/honors/heritage/fellows/fellow.php?id=1995_07 [cited 7 October 2008].

National Park Service Alaska Region. *The Battle of Attu: 60 Years Later*. Available from ublib.buffalo.edu/libraries/e-resources/ebooks/records/efd2929.html [cited 4 June 2008].

Noonan, D. A. *Alaska: The Land of Now*. Seattle: Sherman Printing, 1921.

Powell, Addison M. *Trailing and Camping in Alaska*. New York: Wessels and Bissell, 1910.

Rickard, T. A. *Through the Yukon and Alaska*. San Francisco: Mining and Scientific Press, 1909.

Service, Robert. *The Spell of the Yukon*. New York: Dodd, Mead, and Company, 1907.

Stanley, William M. *A Mile of Gold*. Chicago: Laird & Lee, 1898.

Stuck, Hudson. *Ten Thousand Miles with a Dog Sled*. New York: Charles Scribner, 1914.

U.S. Congress. *Congressional Findings and Declaration: Trans-Alaska Pipeline*. Title 43, Chapter 34, November 16, 1973.

U.S. Fish and Wildlife Service. *Togiak National Wildlife Refuge: Fishing*. Available from togiak.fws.gov/fishing.htm.

U.S. National Park Service. *Aleutian World War II: Stories*. Available from www.nps.gov/aleu/historyculture/stories.htm.

Voice of Alaska. *The Voice of Alaska*. Lachine, Quebec: Sisters of St. Ann Press, 1935.

Washburn, Bradford. *Bradford on Mt. Fairweather*. New York: G. P. Putnam, 1930.

Wickersham, James. *The Fairbanks Miner*. May 1903.

Wickersham, James. *Old Yukon*. St. Paul: West Publishing, 1938.

Wilson, Woodrow. "State of the Union 1913" (speech, 1913). Available from www.let.rug.nl/usa/P/ww28/speeches/ww_1913.htm [cited 3 June 2008].

Worl, Rosita. *Alaska Native Subsistence: Cultures and Economy*. Available from indian.senate.gov/2002hrgs/041702alaska/worl.PDF [cited 17 April 2002].

PHOTO CREDITS

FIRST ALASKANS

Pg. 3: Alaska State Library, Case & Draper Collection, accession number P39-0192

Pg. 4: Albert J. Johnson Collection, accession number 89-166-405, Archives, Alaska and Polar Regions Collections, Rasmuson Library, University of Alaska Fairbanks

Pg. 5, front cover: Crary-Henderson Collection, accession number AMRC-b62-1-a-140, Photographer P. S. Hunt, Anchorage Museum at Rasmuson Center

Pg. 6: Rhoda Thomas Collection, accession number 67-98-389, Archives, Alaska and Polar Regions Collections, Rasmuson Library, University of Alaska Fairbanks

Pg. 7: Clausen Family Collection, accession number 2002-134-56, Archives, Alaska and Polar Regions Collections, Rasmuson Library, University of Alaska Fairbanks

Pg. 8: Alaska State Library, Michael Z. Vinokouroff Collection, accession number P243-3-015

Pg. 9: AMRC General Photograph File, accession number AMRC-b70-28-21, Anchorage Museum at Rasmuson Center

Pg. 10: Margaret Murie Collection—Addition, accession number 1990-3-3, Archives, Alaska and Polar Regions Collections, Rasmuson Library, University of Alaska Fairbanks

Pg. 11: Ickes Collection, accession number AMRC-b75-175-143, Anchorage Museum at Rasmuson Center

Pg. 12: Titus Peter Collection, accession number 1988-96-22, Archives, Alaska and Polar Regions Collections, Rasmuson Library, University of Alaska Fairbanks

Pg. 13: Alaska State Library, Evelyn Butler and George Dale Collection, Photographer George Allan Dale, accession number P306-0616

Pg. 14: AMRC General Photograph File, accession number AMRC-b03-11-4, Anchorage Museum at Rasmuson Center

Pg. 15: Mary Cox Photographs, 1953–1958, accession number 2001-129-63, Archives, Alaska and Polar Regions Collections, Rasmuson Library, University of Alaska Fairbanks

Pg. 16: Ward W. Wells Collection, accession number AMRC-wws-1564-B-11, Anchorage Museum at Rasmuson Center

Pg. 17: Dorothea Leighton M.D. Collection, 1940–1982, accession number 1984-31-23, Archives, Alaska and Polar Regions Collections, Rasmuson Library, University of Alaska Fairbanks

Pg. 18: Wien Collection, accession number AMRC-b85-27-2441, Anchorage Museum at Rasmuson Center

Pg. 19: Wien Collection, accession number AMRC-b85-27-2380, Photographer Wien Air Alaska, Anchorage Museum at Rasmuson Center

Pg. 20: Dorothea Leighton M.D. Collection, 1940–1982, accession number 1984-31-68, Archives, Alaska and Polar Regions Collections, Rasmuson Library, University of Alaska Fairbanks

Pg. 21: Ward W. Wells Collection, accession number AMRC-wws-3421-81, Photographer Ward W. Wells, Anchorage Museum at Rasmuson Center

Pg. 22: Ward W. Wells Collection, accession number AMRC-wws-4077-188, Photographer Wien Air Alaska, Anchorage Museum at Rasmuson Center

Pg. 23: Wien Collection, accession number AMRC-b85-27-2423, Anchorage Museum at Rasmuson Center

Pg. 24: Ward W. Wells Collection, accession number AMRC-wws-4706-58, Anchorage Museum at Rasmuson Center

Pg. 25: Alaska State Library, Ethel M. (Clayton) Montgomery Collection, 1934–1989, accession number P348-238

Pg. 26: Alaska State Library, Kake Potlatch Collection, Photographer George Allan Dale, accession number P263-008

Pg. 27: Wien Collection, accession number AMRC-b85-27-2335, Photographer Frank H. Whaley, Anchorage Museum at Rasmuson Center

Pg. 28: Alaska State Library Portrait File, accession number NativeLeaders-4

Pg. 29: Alaska State Library, Arctic Winter Games Team Alaska, 1967–Collection, accession number P399-0141

RUSH TO GOLD

Pg. 33, front cover: Alaska State Library, Skinner Foundation, Photographs, Alaska Steamship Company Collection, 1890s–1940s, accession number P44-03-015

Pg. 34: Charles Bunnell Collection, accession number 58-1026-1101, Archives, Alaska and Polar Regions Collections, Rasmuson Library, University of Alaska Fairbanks

Pg. 35: Charles Bunnell Collection, accession number 58-1026-2147, Archives, Alaska and Polar Regions Collections, Rasmuson Library, University of Alaska Fairbanks

Pg. 36: "RC Force" Collection, accession number 2003-0174-00172, Photographer Anders Wilse, Archives, Alaska and Polar Regions Collections, Rasmuson Library, University of Alaska Fairbanks

Pg. 37: Alaska State Library, Skinner Foundation, Photographs, Alaska Steamship Company Collection, 1890s–1940s, accession number P226-081

Pg. 38, front cover: Barrett Willoughby Collection, accession number 1972-116-335, Archives, Alaska and Polar Regions Collections, Rasmuson Library, University of Alaska Fairbanks

Pg. 39: Alaska State Library, P.E. Larss Photograph Collection, 1898–1904, Photographer Larss & Duclos, accession number P41-054

Pg. 40: Alaska State Library, Wickersham State Historic Site, Photographs, 1882–1930s, accession number P277-001-200b&w

Pg. 41: V. F. Paul Cyr Collection, accession number 73-50-13, Archives, Alaska and Polar Regions Collections, Rasmuson Library, University of Alaska Fairbanks

Pg. 42: Charles Bunnell Collection, accession number 58-1026-1643, Archives, Alaska and Polar Regions Collections, Rasmuson Library, University of Alaska Fairbanks

Pg. 43: Charles Bunnell Collection, accession number 58-1026-1659, Archives, Alaska and Polar Regions Collections, Rasmuson Library, University of Alaska Fairbanks

Pg. 44: Ralph MacKay Collection, accession number 70-58-507, Photographer E. A. Hegg, Archives, Alaska and Polar Regions Collections, Rasmuson Library, University of Alaska Fairbanks

Pg. 45: Alaska State Library, Alfred G. Simmer Photographs, 1905–1909, accession number P137-038

Pg. 46: Ralph MacKay Collection, accession number 1964-0011-00065, Photographer F. H. Nowell, Archives, Alaska and Polar Regions Collections, Rasmuson Library, University of Alaska Fairbanks

Pg. 47: Alaska State Library, Reverend Samuel Spriggs Photographs, 1899–1908, accession number P320-39

Pg. 48: Alaska State Library, Clarence L. Andrews Photograph Collection, accession number P45-0601

Pg. 49: Albert Johnson Photograph collection, accession number 89-166-658, Photographer Albert J. Johnson, Archives, Alaska and Polar Regions Collections, Rasmuson Library, University of Alaska Fairbanks

Pg. 50: Obye Driscoll Collection, accession number 64-29-66, Archives, Alaska and Polar Regions Collections, Rasmuson Library, University of Alaska Fairbanks

Pg. 51: Alaska State Library, Alaska Electric Light & Power Photograph Collection, accession number P140-038

Pg. 52: Rita Cottnair Album, accession number 1974-130-124, Archives, Alaska and Polar Regions Collections, Rasmuson Library, University of Alaska Fairbanks

Pg. 53: Elsie Blue Collection, Elsie Blue, Photographer, accession number 15-137, Archives, Seward Community Library Association

Pg. 54: Mary Whalen Photograph Collection, accession number 1975-84-229, Photographer P. S. Hunt, Archives, Alaska and Polar Regions Collections, Rasmuson Library, University of Alaska Fairbanks

Pg. 55: Lomen Family Collection, accession number 1965-54-5, Archives, Alaska and Polar Regions Collections, Rasmuson Library, University of Alaska Fairbanks

GROWTH AND EXPANSION

Pg. 59: Alaska State Library, George A. Parks Photographs, George A. Parks, Photographer, accession number P240-390

Pg. 60: Guy Cameron Photograph Collection, accession number 2005-93-8, Guy F. Cameron, Photographer, Archives, Alaska and Polar Regions Collections, Rasmuson Library, University of Alaska Fairbanks

Pg. 61: Lulu Fairbanks Photograph Collection, accession number 1968-69-2923, Archives, Alaska and Polar Regions Collections, Rasmuson Library, University of Alaska Fairbanks

Pg. 62: Candace Waugaman Photograph Collection, accession number 2000-176-104, Photographer B. E. Clemons, Archives, Alaska and Polar Regions Collections, Rasmuson Library, University of Alaska Fairbanks

Pg. 63: Alaska State Library, Dr. Daniel S. Neuman, Photographs, Dr. Daniel S. Neuman, Photographer, accession number P307-0103

Pg. 64: Alaska State Library, Ships in Alaskan Waters, Photographs, accession number 134a-Zapora-1

Pg. 65: National Geographic Society, Katmai Expeditions, Photographer Paul Rarey Hagelbarger, accession number UAA-hmc-0186-volume 4-4112, University of Alaska Anchorage, Archives and Special Collections Department

Pg. 66: John Urban Collection, accession number AMRC-b64-1-259, Anchorage Museum at Rasmuson Center

Pg. 67: Alaska State Library Portrait File, accession number P01-1921, Alaska State Library

Pg. 68, back cover: Alaska State Library, Winter and Pond Photographs, accession number P87-2597, Photographer Ernest Blue

Pg. 69: John Urban Collection, accession number AMRC-b64-1-427, Anchorage Museum at Rasmuson Center

Pg. 70: Alaska State Library, Marguerite Bone Wilcox Photographs, accession number P70-084

Pg. 71: AMRC Wien Collection, accession number 1960-959-21, Archives, Alaska and Polar Regions Collections, Rasmuson Library, University of Alaska Fairbanks

Pg. 72: AMRC General Photo File, accession number AMRC-b75-134-232, Anchorage Museum at Rasmuson Center

Pg. 73: Lomen Family Collection, accession number 1966-54-179, Archives, Alaska and Polar Regions Collections, Rasmuson Library, University of Alaska Fairbanks

Pg. 74: Alaska State Library, Skinner Foundation Photograph Collection, accession number P44-05-217

Pg. 75: Alaska State Library, Skinner Foundation Photograph Collection, accession number P44-05-002

Pg. 76: Alaska State Library, Dr. Daniel S. Neuman Photograph Collection, Dr. Daniel S. Neuman, Photographer, accession number P307-0228

Pg. 77: Alaska State Library, Frederica De Laguna Photograph Collection, accession number P350-33-063

Pg. 78: Alaska State Library, Harry T. Becker Photograph Collection, Harry T. Becker, Photographer, accession number P67-135

Pg. 79: Alaska State Library Photograph Collection, Delano Photo, Photographer, accession number P01-4309

Pg. 80: Glenn H. Bowersox Collection, accession number UAA-hmc-0731-107, University of Alaska Anchorage, Archives and Special Collections Department

Pg. 81: Lomen Family Collection, accession number 1972-71-2415, Archives, Alaska and Polar Regions Collections, Rasmuson Library, University of Alaska Fairbanks

Pg. 82: Albert Johnson Photograph Collection, accession number 1989-166-197, Archives, Alaska and Polar Regions Collections, Rasmuson Library, University of Alaska Fairbanks

Pg. 83: Obye Driscoll Collection, accession number 64-29-313 p043, Archives, Alaska and Polar Regions Collections, Rasmuson Library, University of Alaska Fairbanks

COMING OF AGE

Pg. 87: Historical Photograph Collection, accession number 71-20-09, Archives, Alaska and Polar Regions Collections, Rasmuson Library, University of Alaska Fairbanks

Pg. 88: Alaska State Library, Alaska Highway Construction Photograph Collection, accession number P193-158

Pg. 89: San Francisco Call-Bulletin, Aleutian Islands Photograph Collection, accession number 1970-11-32, Archives, Alaska and Polar Regions Collections, Rasmuson Library, University of Alaska Fairbanks

Pg. 90: Alaska State Library, H. Marion Thornton Photograph Collection, accession number P338-0172

Pg. 91: Alaska State Library, Evelyn Butler and George Dale Collection, accession number P306-1099

Pg. 92: Alaska State Library, Alaska Department of Health and Social Services Photograph Collection, accession number P143-0238

Pg. 93: Alaska State Library, Alaska Department of Education Manuscript Collection, accession number MS146-03-16A

Pg. 94: Alaska State Library, Alaska Department of Health and Social Services Photograph Collection, accession number P143-0807

Pg. 95: Mary Cox Photographs, accession number 2001-129-362, Archives, Alaska and Polar Regions Collections, Rasmuson Library, University of Alaska Fairbanks

Pg. 96: Ward W. Wells Collection, accession number AMRC-wws-156-R23, Anchorage Museum at Rasmuson Center

Pg. 97: Alaska State Library Photograph Collection, accession number P01-3918

Pg. 98: Ward W. Wells Collection, accession number AMRC-wws-2023-6, Anchorage Museum at Rasmuson Center

Pg. 99: Wien Collection, Ward W. Wells, Photographer, accession number AMRC-b85-27-617, Anchorage Museum at Rasmuson Center

Pg. 100: Wien Collection, accession number AMRC-b85-27-313, Anchorage Museum at Rasmuson Center

Pg. 101: Alaska Earthquake Archives Committee Records, accession number 1972-152-4, Archives, Alaska and Polar Regions Collections, Rasmuson Library, University of Alaska Fairbanks

Pg. 102: Ward W. Wells Collection, accession number amrc-wws-5016-6, Anchorage Museum at Rasmuson Center

Pg. 103: Steve McCutcheon Trans Alaska Pipeline System Construction Collection, Steve McCutcheon, Photographer, accession number AMRC-b90-14-3-13, Anchorage Museum at Rasmuson Center

Pg. 104: Steve McCutcheon Trans Alaska Pipeline System Construction Collection, Steve McCutcheon, Photographer, accession number AMRC-b90-14-3-428, Anchorage Museum at Rasmuson Center

Pg. 105: Alaska State Library, H. Marion Thorton Photograph Collection, accession number P338-0743

ALWAYS AND FOREVER THE GREAT LAND

Pg. 109: Clauson Family Collection, P. S. Hunt, Photographer, accession number 2002-134-78, Archives, Alaska and Polar Regions Collections, Rasmuson Library, University of Alaska Fairbanks

Pg. 110: John Zug Album, P. S. Hunt, Photographer, accession number 1980-68-19, Archives, Alaska and Polar Regions Collections, Rasmuson Library, University of Alaska Fairbanks

Pg. 111: Alaska State Library, Alaska Department of Health and Social Services Collection, accession number ASL-P140-014

Pg. 112: Wien Collection, Frank H. Whaley, Photographer, accession number AMRC-b85-27-1401, Anchorage Museum at Rasmuson Center

Pg. 113: Wien Collection, Frank H. Whaley, Photographer, accession number AMRC-b85-27-2705, Anchorage Museum at Rasmuson Center

Pg. 114: Melvin J. Housley Collection, Heath A. Ives, Photographer, accession number 74-63-15, Archives, Alaska and Polar Regions Collections, Rasmuson Library, University of Alaska Fairbanks

Pg. 115: Ralph McKay Collection, F. H. Nowell, Photographer, accession number 1964-111-76, Archives, Alaska and Polar Regions Collections, Rasmuson Library, University of Alaska Fairbanks

Pg. 116: Ward W. Wells Collection, Ward W. Wells, Photographer, accession number AMRC-wws-4260, Anchorage Museum at Rasmuson Center

Pg. 117: Bradford Washburn Collection, Bradford Washburn, Photographer, accession number 2344, Archives, Alaska and Polar Regions Collections, Rasmuson Library, University of Alaska Fairbanks

Pg. 118: Bradford Washburn Collection, Bradford Washburn, Photographer, accession number 3556, Archives, Alaska and Polar Regions Collections, Rasmuson Library, University of Alaska Fairbanks

Pg. 119: Bradford Washburn Collection, Bradford Washburn, Photographer, accession number 7297, Archives, Alaska and Polar Regions Collections, Rasmuson Library, University of Alaska Fairbanks

ABOUT THE AUTHOR

Deb Vanasse came to Alaska in 1979. Her two children were born in the Bush, where boats, snow machines, and small planes are the primary means of travel. Eventually she moved to Fairbanks and then to Anchorage, where she enjoys hiking, biking, and camping. Deb is the author of several Alaskan books, including *A Distant Enemy, Under Alaska's Midnight Sun, Alaska's Animal Babies, Totem Tale,* and *Amazing Alaska.* She is also the author of the *Insider's Guide to Anchorage and Southcentral Alaska* and co-author of *Off the Beaten Path: Alaska* (sixth edition). Visit her at www.debvanasse. com and www.alaskanauthors.com.

Deb Vanasse, climbing the "Golden Stairs" of the Chilkoot Trail. (Photo by Guy M. Ferency)